SIMPSON

IMPRINT IN HUMANITIES

The humanities endowment
by Sharon Hanley Simpson and
Barclay Simpson honors
MURIEL CARTER HANLEY
whose intellect and sensitivity
have enriched the many lives
that she has touched.

The publisher and the University of California
Press Foundation gratefully acknowledge the generous
support of the Simpson Imprint in Humanities.

The publisher gratefully acknowledges the
generous support of the Art Endowment Fund of
the University of California Press Foundation.

Exilée

Temps Morts

flipping through pages keeping a record of time
racing time away from time. we looking below
at villages. it was evening. it was evening fall
inside your arms in three line drawing. bake. slump
travelling through night sleep. dreaming of you
us, there were many, we will always be many.
embracing you sleep, watching you sleep child
face where can i touch you console you hold you
will be many more nights someone else beside you
someone else beside me. going back to the first
time, moments holding each one, feeling them from
other side of the room. rain furiously falling. i let it
empty. you never miss anyone's physical presence
you miss them through silences unfilled - filled
by someone else's presence someone else's time
don't be afraid my darling - you murmur
something i can't understand and it touches so
deeply, so deeply i fall with you on you below you
could you feel me yielding. could you hear me
yielding. can you hear calling welling up in my
throat want you want you it does not matter
does not matter. i want to tape a voice a song a
word, an echo. and it would be nothing more
could be nothing more these words could make so.
sense to you so much no making sense no sense at all
your running your running makes no sense to me
you cry too i cry too time delay this time delay this
make copies only the memory sent to you. how we love
furiously and it's finished it was the sun setting
it was your surrender but we were alone you and me
i tried to refuse refuse but enough tears already fall
maybe come a surprise arrival it would be just like that
instantaneously like that like this a long instant

Theresa Hak Kyung Cha

Exilée

Temps Morts

Selected Works

Edited and with an Introduction by Constance M. Lewallen
With an Essay by Ed Park

University of California Press Oakland
University of California, Berkeley Art Museum and Pacific Film Archive

Contents

Acknowledgments

I am indebted to many people who were instrumental in the realization of this publication. Publications Director Judy Bloch coordinated our various roles and, as always, used a sure but light touch in editing. Chief Curator and Director of Programs and Collections Lucinda Barnes gave us her full support from the outset, and Director of Registration Lisa Calden guided us in the use of these important works in the collection. Thanks also to former Digital Media Producer Jen Pearson, Senior Photographer Benjamin Blackwell, Curatorial Intern Grace Kook Anderson, and Curatorial Associate Stephanie Cannizzo.

My sincere thanks to Ed Park for his perceptive and thoughtful essay.

At UC Press, Laura Cerruti, then poetry editor, was enthusiastic about our initial proposal, and Poetry and Poetics Editor Rachel Berchten guided it to fruition with her excellent judgment and expertise.

The Judith Rothschild Foundation, which helped underwrite our 2001 exhibition *The Dream of the Audience: Theresa Hak Kyung Cha (1952–1982)* and its accompanying book, also provided financial support for this publication, for which we are extremely grateful.

I would be remiss not to thank my husband, Bill Berkson, for his helpful suggestions.

Finally, I wish to thank the Cha family for their cooperation.

Constance M. Lewallen
ADJUNCT CURATOR OF ART, UNIVERSITY OF CALIFORNIA,
BERKELEY ART MUSEUM AND PACIFIC FILM ARCHIVE

Audience Distant Relative

An Introduction to the Writings of Theresa Hak Kyung Cha

CONSTANCE M. LEWALLEN

Theresa Hak Kyung Cha, born in Korea in 1951, immigrated with her mother, father, and two older and two younger siblings to San Francisco in 1964. She came of age as an artist in the San Francisco Bay Area during the 1970s, a decade of enormous artistic, cultural, social, and political transformation. By the time of her death in 1982, she had created an extraordinarily rich, complex, and prescient body of work that reflected not only the profound developments of the time, but also her personal cultural displacement and alienation.

In a 1981 summary of her work, Cha wrote that she had been "working as a visual artist and writer since 1972."[1] Her dual interests are reflected in the multiple degrees she received from the University of California, Berkeley: a BA in comparative literature (1973), a BA in art (1975), an MA in art (1977), and an MFA in art (1978). As an art student, she initially concentrated on ceramic sculpture. However, she was soon introduced to the then new medium of performance under the inspiring tutelage of James Melchert, and subsequently embarked on a series of haunting performances in which she was the protagonist. All were accompanied by her live or recorded spoken words.

The selected writings in this volume, which span the period between 1976 and 1980, will be revelatory to readers who know Cha's work primarily through her highly original postmodern text *Dictée*, published in 1982, only days after her untimely death. Now in its sixth printing and widely used by students and scholars internationally,[2] *Dictée* incorporates family history, autobiography, accounts of female martyrdom, poetry, and images. In this single text, Cha put forth all of her major themes—language, memory, displacement, and alienation, issues that became of major concern to artists a decade later. Although Cha wrote consistently throughout her brief career—including poetry, journal entries, and mail art—apart from *Dictée*, most of her earlier written work is little known, having appeared, if at all, in small-press publications that have long been out of print. With the publication here of two major texts—*Exilée* (p. 31) and *Temps Morts* (p. 59)—and a selection of other writing, readers will have the opportunity to see the artist developing her voice, as well as the multilayered explorations of cultural displacement and the acquisition and analysis of language that culminated in *Dictée*.

As was demonstrated in *The Dream of the Audience: Theresa Hak Kyung Cha (1951–1982)*, a survey of Cha's visual art that premiered at the University of

California, Berkeley Art Museum and Pacific Film Archive in 2001,[3] there was no firm distinction between Cha's visual and linguistic practices. Her performances, documented in photographs and sound recordings, attest to this. Performance, particularly strong in the Bay Area during the 1970s, was one of many new genres being explored by young, adventurous artists eager to escape the restraints of traditional art forms, and its revolutionary spirit was related to the radical political and cultural shifts taking place in society as a whole. During the period from 1969 to 1978, when Cha was a student at Berkeley, the campus was the center of demonstrations against the United States' involvement in the Vietnam War; although Cha was not an active participant in protest activities, she drew upon the spirit of experimentation they represented. In addition to performance, Cha created a number of works in the relatively new medium of video. She also made films and several handmade books, some with photographic images, as well as a variety of other types of text works on paper and cloth. What ties these varied forms together is an emphasis on language, which Cha sought to explore at its most fundamental level. As she wrote, she was "looking for the roots of the language before it is born on the tip of the tongue."[4]

Language, in Korea, where use of the native tongue was suppressed during the Japanese occupation that lasted from 1909 to 1945, is a particularly emotional issue. Moreover, it was fundamental to Cha's experience as a newly arrived immigrant in the United States. Cha observed, "As a foreigner, learning a new language extended beyond its basic function as communication as it is general for a native speaker, to a consciously imposed detachment that allowed analysis and experimentation with other relationships of language."[5]

I have grouped Cha's writings into several sections, which, given the ease with which Cha moved from one form, genre, or language to another and her tendency to combine several genres in a given work, are perforce somewhat arbitrary. The organization is not chronological, but rather based on what seem to be reasonable and useful groupings of similar works or specific projects. The book opens with "audience distant relative" (pp. 18–29), a mail art piece, in which Cha addresses her anonymous readers as she would "a distant relative / seen only heard only through someone else's description." She thus establishes a relationship with us; we are no longer strangers.

Following are the linked texts *Exilée* and *Temps Morts*, second only to *Dictée* in scope and significance. *Exilée* is the text from Cha's eponymous film/video installation. In general, I have not included texts from performances or, as in this case, installations in which they are not the primary element. However, Cha herself believed that *Exilée* could stand on its own, as evidenced by her contribution of the text and its companion, *Temps Morts*, to *HOTEL*, Tanam Press's 1980 anthology of writings by visual artists (including Jenny Holzer and Peter Nadin, Reese Williams, Laurie Anderson, Richard Nonas, and others). The installation *Exilée* was presented for the first time in 1980, but the text appears to have been written in anticipation of Cha's 1979 trip to Korea, her first visit since she left the country of her birth at age eleven. *Temps Morts* is dated 1980 and begins, "it dawns on me just the other day that / i have been back back for months." It also contains several references to Japan, which suggests that she wrote it after a second trip, to Japan and Korea in 1980, for the purpose of making the film *White Dust from Mongolia*, her final, unfinished project, discussed by Ed Park in his essay for this book.

Like *Dictée, Exilée* and *Temps Morts* are titled in French. *Exilée*, or "exiled," refers to Cha's feelings of separation from her birth country. At the start of the text, in a characteristic manner, she plays with linguistic variations (exil, exile, ile, é, ée) that suggest alternative interpretations. The title *Temps Morts*, as in its English equivalent, "dead time," is a double entendre. Cha began learning French in high school, and her involvement with both French language and French culture was intensified by her exposure to Nouvelle Vague cinema while she was studying at UC Berkeley and working as an usher at the Pacific Film Archive.

Part 2 of this volume consists of three distinctive works. The first, "the sand grain story" (p. 89), is a poem that refers to Cha's childhood. It is accompanied by an image of a hand, presumably the artist's. Following this piece is a facsimile of an untitled loose-leaf binder of poetry and photographic images, probably assembled by Cha for a photography class, that also contains childhood memories (pp. 91–111). Here short texts are placed alongside the artist's black-and-white photographs, most of which depict the Convent of the Sacred Heart in San Francisco, which Theresa and her sister Elizabeth attended. The third work in this section is the lighthearted, two-part *Surplus Novel*, which consists of a pair of related texts that read like song lyrics (pp. 113, 115). Cha

cut the typed texts into strips of paper, one line per strip, and presented them in two small porcelain bowls as gifts to her brother James and sister Bernadette (pp. 112, 114).

Cha spent the spring semester of 1976 at the Centre d'Études Américain du Cinéma in Paris through the University of California's Education Abroad Program. She would later anthologize the writings of many of the major film theorists and filmmakers with whom she studied while she was there—including Jean-Louis Baudry, Raymond Bellour, Thierry Kuntzel, Christian Metz, and Monique Wittig—in *APPARATUS—Cinematographic Apparatus: Selected Writings*, a 1980 volume she edited for Tanam Press. In the summer of 1976 she also visited Amsterdam, where she participated in several exhibitions devoted to artists' books and mail art and formed ties with a group of like-minded artists. Her studies in Paris allowed her to perfect her French and reinforced her interest in film, which had been stimulated by her introduction to semiotic film analysis by Berkeley professor Bertrand Augst and by viewing a wide range of avant-garde films at the Pacific Film Archive.[6] During these months, Cha wrote a great deal, mostly poems and diaristic narratives, several of which are grouped together in part 3.

Part 4 contains Cha's narrative description of *White Dust from Mongolia* (pp. 148–154), as well as several related poems (pp. 155–165), an excerpt of the storyboard for the film (pp. 167–169), and four black-and-white stills taken from a short segment of film that James Cha, the artist's brother and cinematographer, was able to shoot before the project was aborted (pp. 170–171).

The final section of the book brings together several works that, like so many of Cha's texts, revolve around wordplay. In the aforementioned summary of her work, Cha asserts her interest in "how words and meaning are *constructed* in the language system itself, by function or usage, and how transformation is brought about through manipulation, processes such as changing syntax, isolation, removing from context, repetition, and reduction to minimal units."[7] A good example of Cha's analysis of words and syntax, as well as her tendency to combine different languages in a single work, is the multisheet *it is almost that* (pp. 193–203), which is the maquette for a slide projection work. *Commentaire* (pp. 205–271), a "commentary" she inserted in *APPARATUS,* is another major work based on word deconstruction. In this filmic, multipage text, Cha thoroughly deconstructs the French word *commentaire* into French and

English components and homonyms (comment, taire, commentary, tear, etc.). In *Faire Part* ("announcement," pp. 175–190), as in *it is almost that*, Cha distributes words and word fragments (in French and English) over multiple pages—in this case, on envelopes.

Cha was murdered in New York on November 5, 1982. She and her new husband and former fellow student, the photographer Richard Barnes, had moved to New York in August 1980, first residing on Staten Island and then in lower Manhattan. At the time of her death, she was teaching video art at Elizabeth Seton College in Yonkers; working as an administrative assistant in the Design Department of the Metropolitan Museum of Art; preparing work based on the depiction of hands in Western painting for a group show at Artists Space; and planning to recast *White Dust from Mongolia* as a historical novel. She had received a grant from the Beard's Fund and had been a guest lecturer at the prestigious Nova Scotia College of Art and Design in Halifax.

Although she lived barely four years after leaving the University of California, Cha produced a stunning body of work in her short life. Sadly, we will never know what this brilliant young artist would have achieved.

Almost all of Cha's visual art and writings, a 1992 gift from the Theresa Hak Kyung Cha Memorial Foundation, established by the artist's family, are in the Theresa Hak Kyung Cha Archive at the University of California, Berkeley Art Museum and Pacific Film Archive (BAM/PFA).

Cha either typed on a manual typewriter or handwrote her texts, but in the interest of clarity, we have typeset most of Cha's writings in this book. This decision was made easier by the fact that the originals are available online through the BAM/PFA website, bampfa.berkeley.edu, or by appointment in the museum's Conceptual Art Study Center. To give a flavor of one of Cha's typewritten pages, we have accompanied the typeset version of a page from "i have time" with a reproduction of the original manuscript page. In addition, an example of an unusual handwritten work appears as the frontispiece. Other works appear as reproductions because they seemed to work best that way—for example, "fly by night" (p. 138).

Our general approach in editing was conservative. Because Cha often deliberately misspelled words, or otherwise altered generally accepted word usage to create double meanings or other effects ("some time" rather than "some-

time" or "inspite" rather than "in spite"), we only corrected spelling in cases where it seemed obvious that the misspelling was an orthographic or typographic error. The same holds true for punctuation, capitalization, and spacing. In the few cases where Cha highlighted words in color, we set those words in boldface.

Since most of the texts were originally written on the broad expanse of 8½ x 11 inch paper, it was often necessary to determine where to break lines on the typeset page. In prose or proselike texts, Cha often set off words or broke lines before the right margin, and in her poetry all lines are flush left; we therefore tried to determine when line breaks were intentional and when not. Runover lines have been set flush left.

Finally, many of Cha's works are untitled. We identify these works by their first line. In the essays and notes, titles conferred in this way appear inside quotation marks; titles given by Cha appear in italics.

1 Theresa Hak Kyung Cha, Summary of Work, Individual Grant Application, National Endowment for the Arts, 1981, UC Berkeley Art Museum and Pacific Film Archive, Theresa Hak Kyung Cha Archive.

2 *Dictée* has been translated into Korean and Japanese.

3 The exhibition was accompanied by a catalogue, for which this volume serves as a companion: Constance M. Lewallen, *The Dream of the Audience: Theresa Hak Kyung Cha (1951–1982)* (Berkeley: University of California Press, 2001). The exhibition subsequently toured throughout the United States, as well as to Seoul, Vienna, and Barcelona.

4 Cha, Summary of Work.

5 Theresa Hak Kyung Cha, Personal Statement and Outline of Independent Postdoctoral Project, submitted for Chancellor's Postdoctoral Fellowship, UC Berkeley, 1979, Cha Archive.

6 At the Pacific Film Archive, she had the opportunity to attend talks by Michelangelo Antonioni, Michel Foucault, Alain Robbe-Grillet, Werner Herzog, Marcel Ophüls, Bertrand Tavernier, Frederick Wiseman, and Wim Wenders.

7 Cha, Summary of Work.

"This is the writing you have been waiting for"

I

For a writer whose most visible work, *Dictée,* brims with saints and martyrdom and the possibilities of productive anguish, it's fitting that this gathering of Theresa Hak Kyung Cha's disparate uncollected writings—everything from artists' books to typewritten *disjecta membra*—should give off the refulgent glow of relics set against plain white cloth. Since there will be no new writing from the late author, every word counts. Indeed, for an artist so committed to permutations of language—to literally mincing words, teasing meanings from amputations, one character at a time—every *letter* counts. Is a crossed-out line or seeming typo in fact some intimation of wordplay, language on the verge of creative unraveling?

Cha was only thirty-one when she was murdered in New York on November 5, 1982, shortly before the publication of *Dictée.* From the very first edition, then, everyone encountering *Dictée* has incorporated this grim fact into the reading experience. Over a quarter century after the book's publication, that shadow has soaked into its very fibers. Every sentence is haunted by what is about to be.

Yet despite its somber tone, *Dictée* is not a tomb, but something that remains vividly alive: an explosion of high-wire techniques and wide-ranging influences, a feat of historical imagination, a multimedia display, an eloquent stutter. Recto and verso narratives interlock, the text of one page fitting erotically into the white space on the other. An anatomical illustration of the chest and throat is followed by a map of divided Korea. Language breaks down, starts up, transposes itself from French to English, becomes a deadpan grammar lesson. It ends near glossolalia. The epigraph is from Sappho, whose surviving work consists almost solely of fragments.

Those who have heeded *Dictée*'s complicated call will find much to savor in the writings collected here: Cha's adventurous spirit is present in even the least of these works, a breath of a bygone avant-garde that still hits its mark with astonishing frequency. But *Exilée and Temps Morts: Selected Works* isn't only for completists and converts. Even readers unacquainted with *Dictée* will be rewarded with an unusual story—one as gripping as anything in Cha's most famous and fully realized work.

II

In one of the untitled selections that make up part 3 of this collection, "i have time" (pp. 120–127), Cha writes: "this is a book. i have an excuse. any excuse. all excuses. this is a book. its length, its content, fiction or no fiction, is true." When we write to ourselves—diaries, notes—we confess with an intensity otherwise hard to access. We spin world-shaking schemes, sketch the first lines of impossible books, revel in delusions of grandeur that we helplessly multiply. Continuity, even logic, is optional. We are free to contradict ourselves. Around two years later, Cha would write: "in delirium it's fiction. its fiction / from left hand corner to the right hand corner. from left to right" (p. 143). Has the antecedent changed? It doesn't matter. Even an author of many books only ever writes one book.

This (momentary) siding with fiction comes from an untitled typewritten page beginning "writing conscious-unconsciously," a good description of Cha's modus operandi for the fugitive pieces of part 3. The texts are restless, cacophonous, melodious, occasionally oppressive, and fascinating. They exist in a liminal state, between raw wordage and cohesive poetry, solipsistic auto-reportage and inspired juxtaposition. "[T]he sins documented and erased the constant tides of recording and erasing," she writes in "i have time," as if in thrall to such inchoate productivity, a little anxious at the prospect of ceaseless verbiage. These writings are many things: stopgap measures; a musician's obsessive tuning; the shadow output that every artist generates, draws secret sustenance from, and risks vanishing into.

The writer of "i have time" makes cryptic pronouncements, fashions and abandons odd lists, and eventually creates a character of sorts (a maid) that stirs enough interest as a potential narrative that Cha appends a handwritten note, fleshing out a possible scenario. There is a "scattered alchemy" to her cataloguing of household materials, which she wryly follows with "recipe for salade niçoise." Someone (a man?) scolds her: "all the years you spent here all the literature courses you studied is this what they taught you i can't understand a thing my dictionary has no translation of this."

The tension sends the reader backward, fruitlessly searching for the glimmer of a narrative thread, anything about this rebuking voice. But Cha, or the artist figure implicit in the writing, asserts herself with superhuman might: "this is the essay this is the fiction this is the poetry this is the novel this is the writing you have been waiting for." These pages were all started simply to fill

a gap in the day ("i have time," the stumbling admission in "fly by night" that "i wanted to wrtie *[sic]* write something before i become too sleep y" [p. 138]). But lines like this one slice through the insomniac murk, and suddenly not just a stretch of jagged typewritten coastline, but the whole strange realm of Cha's oeuvre bears a fresh motto. This is the writing we have been waiting for.

III

Exilée (p. 31) and *Temps Morts* (p. 59) first appeared, together, in the anthology *HOTEL*, published in 1980 by the New York–based Tanam Press. Boxed before the ink was dry, the copies of *HOTEL* stuck together; nearly three decades later, separating one for further study requires tearing it from the pack, unavoidably damaging the glossy cover. A palimpsest of the contents printed on the back now mars the front; a bold *H* or *L* from the front finds itself transferred on the back. The book looks like the sides of those ancient buildings in New York that a nearby demolition will suddenly expose, on which traces of old painted advertisements linger, ghost texts. In other words, the perfect cover to house a work by Cha.

Exilée, Temps Morts: These titles represent distinct works, but their adjoining suites in *HOTEL* suggest that we read the titles together. For Cha, the condition of exile *is* dead time (*temps morts*), however fertile it may prove for creative work (Joyce's credo: silence, cunning, exile). As with *Dictée,* the title itself performs an initial alienation—French instead of English, which conjures Cha's more primal exchange, English instead of Korean.

Thus one might expect a dry run of *Dictée*'s themes and methods, yet *Exilée/Temps Morts* (as we shall call it) is no mere sketch, but a fully formed triumph, an echo chamber aerated with a subtle stream of laughing gas. Page-spanning *X*'s appear in *Exilée*, but that's as elaborate as the graphics get; everything else is text and white space. On this smaller canvas, without *Dictée*'s intricate architecture and visual apparatus, the words take center stage. Cha's lines achieve a quiet grace—

meanwhile
it might be time for at least one light
in this three mat room

—or clatter into compelling repetitions and mutations—

take are taking took have taken have been taking
have had been taking had taken will take will have
been taking will have taken will have had taken.

There is more humor in *Exilée/Temps Morts* than in the entirety of *Dictée*:
"she is asked with enthusiasm / who is being exiled that is the title what does
/ it mean who are you." Even as the text turns on itself, Cha is able to play the
interrogation for a laugh as well. One of several seemingly found texts is a
business letter (beginning "Dear Colleague"), which gassily expounds on the
concept of "future shock" before dissolving into a hilarious traffic jam of verb
tenses. A menu (apparently from her trip, that year, to Japan) is reproduced
with this header:

YESTERDAY WAS WEDNESDAY
TODAY IS THURSDAY
TOMORROW WILL BE FRIDAY

This language-lesson formulation, repeated across a week, accrues shades of
homesickness and desperation, like hotly telegraphed panic signals of some-
one counting the days till freedom.

Time and again her words self-destruct, sentences dissolving to expose the
very skeleton of language, the limit of sense: "noun verb adjective article" at
one point, shards of a Dick and Jane primer at another. "[N]o other cure none
other than words," Cha writes. A cure for what? It is a curious cure, involv-
ing constant breakdown—but perhaps the speaker or writer is inoculating her-
self with the base elements of language against some bigger breakdown, loom-
ing off the mind's horizon.

IV

Of the numerous acute themes and settings in *Exilée/Temps Morts*—you
couldn't call them plots or scenes—the most poignant involves an obsessive
calculation of the time difference between the West Coast of the United States
and Korea. The telephone operator

tells me it is sixteen hours
sixteen hours from here a head

ahead of this time she says, if it is four thirty
p.m. here, it is eight thirty a.m. there.

A painstaking calculation follows, so that "seven thirty" is translated, hour by hour, to the Korean hour of eleven thirty. Korea is always in the future. The irony is that for Cha, Korea is the past, *her* past.

If *Exilée/Temps Morts* is a triumph, the remnants of *White Dust from Mongolia* (pp. 148–171) represent a crucial defeat. Cha planned for *White Dust* to be filmed in Korea, where she had been only once (in 1979, when she began work on the project) since emigrating to the United States in 1963. The film would have two narratives and three voices, a textured polyphony akin to that of her written pieces. Surviving storyboards and footage feature public spaces, trains, close-ups of hands. The nameless, amnesiac female character functions as a catchall metaphor. Typewritten texts related to *White Dust* exhibit Cha's trademark tension between the impossibility of language ("could not bear to say [. . .] without a single sound without a single voice") and its inevitable unleashing ("by train going to school by train through dark tunnels the smoke comes in if the window is not closed everyone screams when the tunnel comes"). But Cha's lacuna-filled approach to the past—to *her* past—could not withstand an actual encounter with that past, as we shall see.

Where does exile end and life begin? Cha's unusually long academic stint (resulting in two bachelor's degrees and two master's degrees) reflected a devotion to art making in various mediums. But if life in Berkeley and briefly New York was fecund, it was also a dead time. As abstract as much of her description of *White Dust* sounds, she stressed (in a 1981 grant application to the National Endowment for the Arts) that the film would be about "my return to the time and space that was once left, that only existed in memory until the void between the two separate spaces and time *[sic]* are able to be filled, by the actual return to the place, in this case, to Korea, which I have left 17 years ago."[1]

In a postdoctoral fellowship application she submitted the same year for continuation of work on *White Dust,* she stated, "My work, until now [. . .] has been a series of metaphors for this return."[2] Clearly, the metaphors were in place *before* she left for Korea; they were in line with what we know of her other work. Rather than landing in Korea and seeing how it might inspire her, Cha had mapped out the film beforehand.

She came to Seoul in the midst of a particularly turbulent phase of Korea's reliably turbulent twentieth-century history. Her film project was to be *about* history—*White Dust*'s anonymous protagonist would be a metaphor, Cha wrote, for "nation, a historical condition"[3]—but came to a halt *because* of history, because of events that she couldn't have predicted.

Put another way: Cha's rather abstract, dream-state conception of history ran up against, was broken by, *real* history: the violence of modern Korea. President Park Chung Hee had been assassinated in October 1979; the following spring saw the bloody Kwangju uprising, in which civilian opposition to Park's successor, former general Chun Doo Hwan, was brutally suppressed. There was unrest in the streets, tension everywhere. In a grand irony, Cha and her brother were harassed as they tried to work on their film, possibly suspected of being North Korean spies. Perhaps *this* should have become the topic of her film; instead, the chaotic conditions would doom the production. The abandoned film would become an unfinished book, but it doesn't appear that she made any concessions to the reality of what she had witnessed in Korea.

"She is without a Past," Cha remarks about her character in a description of *White Dust*, written while she still planned to make this film in Korea—that is, in her past. The problem with amnesia is that it's so rare as to be exotic; it can give ludicrous power to a mystery story or thriller, but otherwise risks sinking a work into fussy abstraction. How did Cha intend the "void" to be filled? The grievances of Korea find a place in *Dictée*—Cha reproduces a pathetically polished 1905 letter from Syngman Rhee (future first president of South Korea) to Franklin Delano Roosevelt—but there were more immediate rumblings that, living in America, Cha didn't seem to register. Hoping to make a film along the lines of her artfully assembled history, Cha collided with the actual history that surrounded her as soon as she set foot in Seoul. The country had not fossilized after she left in the 1960s. It was not waiting for her writing.

White is a funerary color in Korea; death suffuses *White Dust from Mongolia*, even in its incomplete state. Or you could say that it exists *in toto*: that this project in fact lives in its rubble, exists in its very dust, the dust of failure—something perhaps Cha sensed even as she tried repeatedly to resurrect it. Something, perhaps, she had known the moment she came up with the title.

1 Theresa Hak Kyung Cha, Summary of Work, Individual Grant Application, National Endowment for the Arts, 1981, UC Berkeley Art Museum and Pacific Film Archive, Theresa Hak Kyung Cha Archive.

2 Theresa Hak Kyung Cha, Personal Statement and Outline of Independent Postdoctoral Project, submitted for Chancellor's Postdoctoral Fellowship, UC Berkeley, 1979, Cha Archive.

3 Theresa Hak Kyung Cha, film scenario for *White Dust from Mongolia,* 1980, Cha Archive.

1

audience

distant relative

you are the audience
you are my distant audience
i address you
as i would a distant relative
as if a distant relative
seen only heard only through someone else's description.

neither you nor i
are visible to each other
i can only assume that you can hear me
i can only hope that you hear me

letter

sendereceiver

this is a letter read aloud.
upon opening it
you hear the sender's voice as your eyes move over the
words. you, the receiver, seeing the sender's image
speak over the
voice.

object/subject

in our relationship
i am the object/you are the subject

in our relationship
you are the object/i am the subject

in our relationship
you are the subject/i am the object

in our relationship
i am the subject/you are the object

messenger

the messenger, is the voice-presence
occupying the space,
voice presence occupying the
time between.

between delivery

from the very moment any voice is conceived whether
physically realized or not
manifested or not
to the very moment (if & when) delivered

echo

the in-between-time: from when a sound is made
to when it returns as an echo
no one knows if it was heard,
when it was heard
when it would be heard
if ever at all
but it continues on and on and on
maybe thousand years

 someone's memory
 tale
 legend
 poem
 dream

 '

EXILÉE

EXIL
EXILE
 ILE
 É
 É E

BEFORE NAME
NO NAME
NONE OTHER
NONE OTHER THAN GIVEN
LAST ABSENT FIRST
 NAME
WITHOUT NAME
A NO NAME
 NO NAME
BETWEEN NAME
NAMED

There. has begun. already
there. room. rooms. as is. all left as is.
from the Inside
white inside white white noise white wind
snow. shades. light wind shadow
There. has started. is on the way.
there already already past and
already again there. room. rooms.
white ringing room.
rooms. from the Inside.
wind. shadow. in the shade.

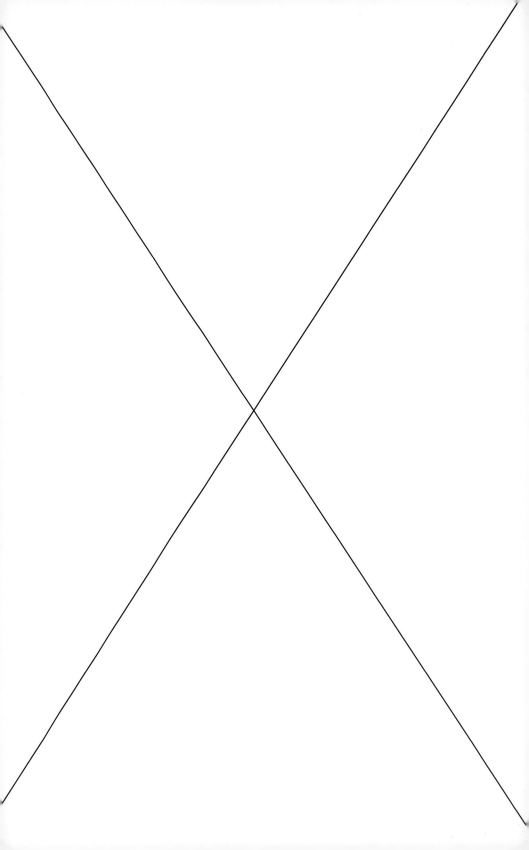

And Now. Now between and outside
from Outside.
in between the one actual
to the another actual present.
how many present. how many. simultaneous.
alternate.
following daylight to the end.
of daylight

ten hours twenty three minuits
sixteen hours ahead of this time

ten hours twenty two minuits
sixteen hours ahead of this time

ten hours twenty one minuit
sixteen hours ahead of this time

Backwards. from backwards from the back way back.
to This This phantom image/non-images
almost non-images without images. each ante-
moment moment no more. no more a moment
a moment no duration. no time. phantom no visible
no name no duration no memory no reflection no echo

Twice two times two
has been said one on top below of another one.
before the other one arriving following
the next other
twice two times one on top below another one before
the other arriving following the next one

From the outside, outside of all extra remaining,
the extra as the only part shaded in. in shadow.
the only seen imaginable image was the extra
mark left behind
lights darken
elapse. more so than ever. more than ever.
more than ever before. even more. the attendance.
attending. waiting on. waiting upon. waited.
waited upon. weighed. a sequence. a chronology.
the only seen from outside was imagined was shaded
in or left unmarked was dreamed was erased was
fantasy was phantom

Of previous. souvenirs. remnants. previously
recent. recent past. in tenses. in conjugations.
in numbers. in chronologies.
plural pasts taken place beforehand
in articulations tongues
taken place beforehand
abolition effacement
the one place the one thing the only thing
the only place replaced with tenses with conjugations
with numbers with chronologies
plural pasts taken place beforehand

It waits it knows not not to wait
on the other side facing sideways in backwards
time from backwards
taking time. just a matter of timing.
biding time. it waits.
the other side from backwards reversing to face
This waiting to face the other direction
in advance as is either or both as comes.

Less and less least of all
things
of lesser
things shadows certain.
certain times. definite. definite times.
least of all shadows at most at most
certain times.
Here. to have happened. unavoidably
spectre uniformly scattered uniformly lit
exact. without defining. defining all the same.

There. has begun. already. as is
all left as is. there. room. rooms.
from the inside. white. inside white.
white noise. white wind. snow. shades.
light wind shadow
there has started is on the way there
already. already past and already again there.
room. rooms. white ringing rooms.
from the Inside. wind. shadow. in the shade.

As a standard mark a standard marking
maintained as a marking, repeated, has been always
repeated as long as i can remember, started before,
even before my time.
traced as standard procedure for marking

(repeated as invocation
 of that one thing that only one thing
 the one thing and the one place)

can't be helped. from the beginning as repeated
as standard mark standard wound
just one more name by chance one more given not
to be repeated again by chance. by chance there,
to be repeated again to remain as marking as wound.

Deny.
either two. both.
either only as otherwise only as elsewhere
PRESENT ACTIVE
PRESENT PASSIVE
PRESENT ACTIVE
PRESENT PASSIVE
either both modified sentences
phrases
tenses
moment by moment modification
modified duration
sentence. phantom phrase for absence's shadow
absence's own. as own, phantom definitions.
destinations.

NAME—NOM

SEX—SEXE

BIRTHPLACE—LIEU DE NAISSANCE

BIRTHDATE—DATE DE NAISSANCE

WIFE/HUSBAND—EPOUSE/EPOUX

X X X

MINORS—ENFANTS MINEURS

X X X

ISSUE DATE—DATE DE DELIVRANCE

EXPIRES ON—EXPIRE LE

some door some night some window lit some train some
city some nation some peoples
Re Named
u tt e r ly by chance by luck by hazard otherwise.
any door any night any window lit any train any city
any nation any peoples some name any name to a
given name

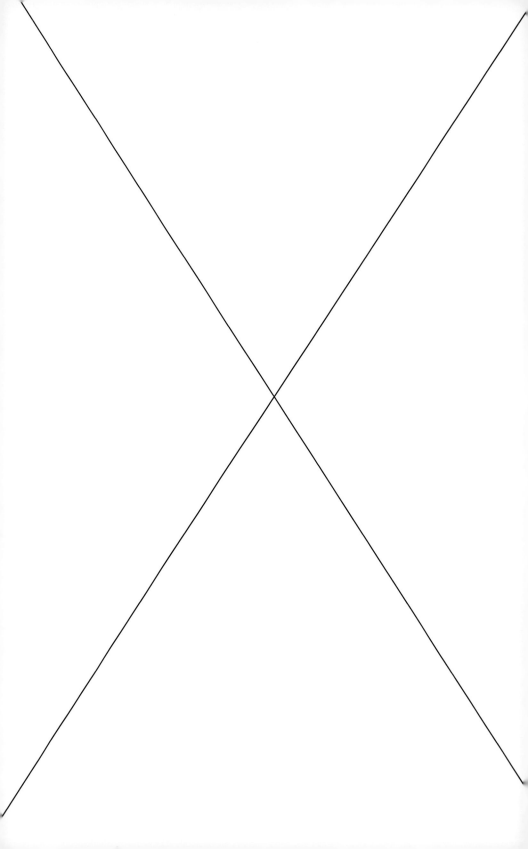

Moved in towards Time. continued to disappear
little by little in parts. from limb to limb.
just to the end. and towards the end, over again
little by little, in pieces.
night fell. twice over. it snowed.
it was forgotten. a few steps away. from the room.
a few steps. two or three. arm's length.
from the outside the windows slid.
forgotten white. a view, towards the end,
from the Inside of all that would ever be ever
Inside. buried. end to end. forgotten.
over and over

TEMPS MORTS

it dawns on me just the other day that
i have been back back for months
that i have lived here since then
it starts without me
it started without me
i was here all time
it started inspite
it starts whether or not
perpetually
without knowing itself even starting
designated designated time-movement
starting on time on time
no acknowledgement of time
no indication
no forecast
all the while i have been gone
continued to do so as is
otherwise
elsewhere
nothing altered as is as had been always
looking back trying to look
back as it would start no start
as it would continue

close door here just as soon as closing
as closing
behind

looking back
backwards two steps inside
one forward at doors ledge
in between
behind a long time ago closing remembered to
close turn key the upper lock as well and steps
downward past two windows side by side white
frames white gauze able to see out but not in
except at night when lights are on

meanwhile
it might be time for at least one light
in this three mat room
at least
plus six more joining on the other side of the
partition removed for the open nine mat area
single room
two closets one mat each possible to fit
sliding window doors a wooden ledge knee high
to outside yard the corridor to the front door
walkway to front gate to street
hourly music box melody indicating 8 o'clock
arbitrary hour
one alarm 8 o'clock
single file the line of suited men as they pass
the gate turning the corner

purposefully. crossing the "enemy" line.
the enemy. before the conception the meaning of
word "enemy" and already enemy.
my mother's.
my father's.
my mother's mother father.
my father's father mother.
if i had children theirs as well
if the conditions were such.
in search of through which finally my own proper
identity can be retrieved. through the enforcement
of identity here the doubling of identity
the double estrangement.
asset: invisibility of another tongue the tongue
now permanently forgotten would be no shame to have
to have known. to have had to have utilized.

planted streets with PA systems the always female
voice the most soft most convincing most meek
most perfect etiquette perfect
perfected throughout the centuries the skirt
binding layers around her bodice her confinement
her sex her revelation her sin forgiven shame
concealed with one pair white underpants barred
chained is her erotic disposition bought as
nourishment not unlike nourishment through
vending machines

she is asked with enthusiasm
who is being exiled that is the title what does
it mean who are you what is the explanation of/for
this why is it not in this language how long is it
the explanation today not tomorrow today at the
latest in a few hours

in a few hours
the walls are lined with metal not even ambient
sound occasional metal echo the next door closing
maybe some one else next door
his name the dinner menu that year
some sunday a well known holyday his name
five letters his last name that is some sunday
only because of the classical music down below
and the coughing the music opera or something
and the cough only because of that there again
the coughing
number rather than name not zero one to ten
let's say one to a hundred one to a thousand one
to a million might as well be a million a million
through and past zero already
not already as in it's sunday already
already as in one to a hundred a thousand times
already
already - as in came and went
already - as in came and went a hundred times
 at least

Dear Sir,

I have previously written

Dear Sirs,

It is at this time I would like to
inquire about a letter

Dear

Sir and Madam,

I am writing to you in regards to a letter
I have sent dated

Dear Madame

she occupies one large room one large wall
to herself
adjacent to this room three others
speak
how beautiful she is
nu from her chest upward
her naked hand on her right shoulder not quite
touching her nu face eye lids mouth hair ears nu
absolutely
she was his double image striking resemblance
reminiscent spitting image of he
her glance is towards the earth
as about to speak
from
above
as though all gazing upon her
from
below
she our lady of madonna holy mary immaculate
conception mother of god praying for her sinners
now and at the hour of our death
she was made avowal to sign a contract before
betrothal that she would not bring suit against
him in case of divorce that she was not only
marrying him for money
voices enter into the large room the eyes move
upward towards her
she did it anyway
as the holy ghost descends upon her annunciation
her ascension immaculate conception of thy womb
she occupies one large room one entire wall
to herself
fixed white flat surface
through glass her gaze
translucent
measures 67 1/2 inches from floor 5 inches
from left corner

she tells me it's always the woman operator
she tells me it is sixteen hours
sixteen hours from here a head
ahead of this time she says, if it is four thirty
p.m. here, it is eight thirty a.m. there.
the next day.
if it is twelve midnight here, it is four a.m.
there the next day.
if it is seven a.m. here it is eleven p.m. there
the next day seven or seven thirty

eight thirty	-1
nine thirty	-2
ten thirty	-3
eleven thirty	-4
twelve thirty	-5
one thirty	-6
two thirty	-7
three thirty	-8
four thirty	-9
five thirty	-10
six thirty	-11
seven thirty	-12
eight thirty	-13
nine thirty	-14
ten thirty	-15
eleven thirty	-16

that would be the right time precisely just right
it's ringing at the other end all these months
she tells me it's sixteen hours ahead then the
other night she tells me it's seventeen
midnight there the next day always

walking into the water into the tides wearing
it's in black and white the waves tides come
still walking into water knee deep into waist
deep into chest deep for to meet with to make
invincible compress seventeen hours what used to
be sixteen it's this ringing at the other end
station to station neck deep it's in black and white
sheen of white foam the iridescent grey foam
silver pearline
at the edge of this tip water rope and stone tied
at the end keep throwing it might land at the
other edge seventeen hours ahead tomorrow there
what used to be sixteen

it's enough. from this point.

from this point on. past is past it's just the past
only the past

it's enough without the if and then if thus then so.

it would have. it would of.

from There would be looking back

This would be looked back already looking There

so This can be looked back

already as if

how it would be all This as proceeds as it is

proceeding from There as sought each by each

each step by each step

sought from There

recule renverse en arrière
advance for the sake for the sake of
reversing to collect memories
advance from now just to remember what it was like
before it was not it has not it is not
it is in place once forward one back
who has them that has not even occurred
who has them that has not even
whose memory who remembers who gave it away
there was none never was
advancing memory collecting memory just to
just look back in advance for souvenirs
happened or not happened at all

How many times have you heard (or even said),
"If I knew then what I know now . . .

Dear Colleague,

It's amusing. But serious. You make decisions
everyday; large and small. Decisions that could and often do
affect your profession, your life-style, where you live and
even with whom you live. They are important and necessary
decisions that could have a far-reaching impact on your life
not just today but in your future as well.

Far too often in today's quick-changing, fast-paced
world, new events and trends come along that can catch us
off-guard and lead us into the dim world of "future shock,"
the disorientation that occurs when the world changes
faster than we can rearrange our thinking patterns, attitudes,
and values.

It doesn't have to be that way. Not if you

take are taking took have taken have been taking
have had been taking had taken will take will have
been taking will have taken will have had taken
know are knowing have known have been knowing
have had been knowing had known will know will have
known will have had known say are saying said have
said have been saying have had been saying had said
will say will have said will have had said decide
are deciding decided have decided have been deciding
have had been deciding had decided will decide will
have decided will have had decided change are chang
-ing changed have changed have been changing have
had been changing had changed will change will have
changed will have had changed live are living lived
have lived have been living have had been living had
lived will live will have lived will have had lived
buy are buying bought have bought have been buying
have had been buying had bought will buy will have
bought will have had bought

two. one for me and one for you. two pieces.
for dinner. head intact. gutted. blood and water.
on white sheet. plastic bag. salted. it turns
color. rainbow kerosene stain floating on rain
puddles turning my stomach. tail black v. or w.
scales layered clear sequins popping and falling
with each scrape. newspaper on the floor. missing
the paper. picking one by one off
the head is the best part. sucking on the bones
crevices at the market the fillet in wrapped cellophane
it's just called fish. it's not fish. no bones.
no skin. no head. no scales. i caught it in the
pond planted trout farm i went fishing i had a tackle
a line a hook i caught one. it was jumping.
i tried to take it off i tore its mouth it flaps
it feels something it bleeds i can't do it the
bucket is full the bucket stops moving
in the back the concrete slab installed for washing
laundry washing rice water pump water well rice
closet. basin glimmering in afternoon sun soaking
those gauze pieces again pool of red dye looks
like blood must be from that gauze diaper pool red
dye basin yellow tin glimmering outside sunlight
beside the small door connecting the yard to the
kitchen. must be from that. the gauze hung out
to dry i heard them fighting i heard her cry i saw
her eyes the basin put there without lid white
gauze bleeding
in three parts soprano mezzo soprano alto
sacred heart of jesus bleeding
heart from which the heavens draw their glory oh
thou world conquering heart
thou only thou only thou only heart of hearts
may thy kingdom come may thy kingdom kingdom come
a men a men
may the day of thine infinite love come quickly
two. i bought two. one for you and one for me.
for dinner. salted. grilled. i like it hard.
not soft. not fishy. not friday.

comes it comes away it comes from it comes
away with
hanging mouth open
comes away speechless
not to mention stuttering not to mention disorder
noun verb adjective article verb before noun
article at the end double negative pauses
loitering repetition i mean this is what i mean
what i want to say is what i want said
finally i don't know that's not what i meant
i don't mean that not that way not really
in one sense maybe in a certain sense sort of
it's sort of like that it's like as if
kind of like on one level in terms of i don't
know for sure in a way not to mention replacing
the subject with the wrong word most likely
from all the words beginning with a

ablution
absolution
abstinence
abstract
abuse
abvolate
abysm
acanonical
accent
accidie
account
accretion
adamite
adar
adevism

i didn't say anything not anything like that
nothing not nearly that not to mention
how you said how implied
cure all magic potion better than anything
any other
words cure all magic
it was like this; see
spot see
jane see
dick
spot run see jane run see dick run
run run run
dick see spot run
see see see
jane see
dick see
spot see
not to mention days of the week
months of the year
i pledge allegiance
readings from saint mark standing up
paradise lost
and the preamble

no other cure none other than words in talking
in speaking your mind in speaking up in speech in
discussion in instruction in contracts in commandment
prescription reclamation decree dictation mandate
pronouncement manifesto notification passport
citation plebiscite appeal title confession verdict

DAYS OF THE WEEK:
YESTERDAY WAS SATURDAY
TODAY IS SUNDAY
TOMORROW WILL BE MONDAY

rain reducing long waited plum blossoms to the
ground this street white fish scales still falling
falling
sunday
sunday might have been kokubunji suburbs tokyo
walking paths through bamboo the vegetable man crouch
crouched washing white daikon turnips in narrow
stream piles on side brilliant white
might have been kokubunji suburbs tokyo sunday paths
through smoke burning leaves pungent fragrance
might have been kokubunji suburbs tokyo sunday temple
incense some tourists on bikes drink water from small
well same ladle as woman keeper opens to inside white
rope hanging goes nowhere begins nowhere
afternoon shadow moves
all the bedding taken in for the night
a chain restaurant semblable Denny's Sambo's any
freeway some modification Coq d'Or this chain is
called Coq d'Or all dish models confection and
patisserie in bright vitrine
all menu lined from milk shakes rainbow color
to frog legs ingenious layout precariously positioned
five rows perfect 45 degree angle
booths synthetic orange leather plastic encased
cardboard menus corn potage soup beef stroganoff
side dish of rice hair thin sliced western cabbage
with worcestershire sauce coffee american cream
five or six waiters waitresses hovering five
different tones please come in please come in please
come in please come in thank you very much thank you
very much thank you very much thank you very much
thank you very much please i am sorry please let me
pour you more ice water
duplication 1X1-2 2X2-4 3X3-9 4X4-16
 5X5-25 6X6-36 7X7-49 etc.

two pork buns
steaming
inside plastic bag
fifty yen each
dusk
from the street
rooms are lit
one by one

YESTERDAY WAS SUNDAY
TODAY IS MONDAY
TOMORROW WILL BE TUESDAY

groupings. sets. two by two across black suit
blue tie grey tie black shoes starched white collar
blade into neck bundles wrapped purple cloth each
lap square same purple bundles.

YESTERDAY WAS TUESDAY
TODAY IS WEDNESDAY
TOMORROW WILL BE THURSDAY

groupings. sets.
single view of man chef white cloth tied from back
of the head to front of the head white shirt bib
towel around waist
only view of tub wooden bamboo braids full white rice
rocking motion of man chef left to right left to
right left right left hand to right hand left hand
right his shoulders his neck his head left to right
ball of rice left hand right hand one every three
seconds green mustard with his right hand brushed
on top left hand right hand rocking
turning automated conveyer belt rack motion
clock-wise as dishes lifted dishes replenished
and the rocking left right
and the motion conveyer belt as hands reaching
dishes lifted dishes replenished
salmon eggs on top of brushed mustard on top of
rice ball
square shaped egg layers
octopus
tuna
eel
urchin
fermented tofu
bass
red diced ginger
spinach
squid
mackerel
just as soon as lifted just as soon replenished
eel salmon eggs octopus urchin bass fermented tofu
spinach omelette layers bass red ginger diced
mackerel tuna squid

YESTERDAY WAS WEDNESDAY
TODAY IS THURSDAY
TOMORROW WILL BE FRIDAY

groupings. sets.

lunch set:

sandwich	eggs and ham	coffee
	cheese and ham	
	vegetable and ham	
	cheese and vegetables	
	combination	

| pork cutlet spaghetti | rice |
| shredded cabbage | coffee |

fish fry	rice
jambon	coffee
crab croquette	
potato croquette	
shredded cabbage	

yaki niku	rice
miso soup	green tea
daikon slice	

YESTERDAY WAS THURSDAY
TODAY IS FRIDAY
TOMORROW WILL BE SATURDAY

groupings. sets.

gift set:

Maxim coffee regular 4 oz. two jars
Maxim coffee decaffeinated 4 oz. one jar

one bottle Suntory Whiskey
two Suntory Whiskey etched glasses

Lux bar soap set of 12

Chocolat Swiss set of 24

Bonbons Francais set of 36

Gateaux Japonais set of 12

MONTHS OF THE YEAR
(black letters on white)

fade in from black to JANUARY fade to black
FEBRUARY fade in from black MARCH dissolve 10 sec.
to APRIL hand turning page to MAY 10 sec. cut to
CLS JUNE quick dissolve to JULY -1, -2, AUGUST -3,
SEPTEMBER fade to black, very slow up on OCTOBER
fade to NOVEMBER equal time, slower fade to DECEMBER
very slow fade out. black.

water touches it and makes moist cracked surface
skin only lips move make shapes
shapes invade the form the instrument
examine every letter
of the word each word each comma each period
each parenthesis spaces between letters
between lines for other thing stains creases
skinning each sheet no to touch the sheet
not at all
deft to admonishment to oracle to prediction
to mysteries to revelation to muses nine daughters
Mnemosyne
water stains ink stain page after page absorbs
imitation multiple echoes beneath swallowed through
the hollow of ears of throat chest womb blood and
water through the hollow of voice back voice arm
voice hand voice eyes voice head loss through
osmosis precipitation crystallization perished
waters lethe waters oblivion

Drink oblivion of their former lives

O father is it possible that any can be so in love
with life as to wish to leave these tranquil seats
of the upper world

Having had the remembrance of their former lives
effectually washed away by the waters of lethe

Gr. letho, latheo, lanthano, to cause persons
not to know that they may forget everything
said and done when alive

memory less image less
scratches rising to bare surface
incision to lift incision to heal

2

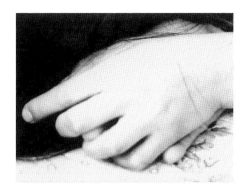

this is one of the pages
where the sand grain story begins.
this is one of the pages
where the sand grain kept itself.
has since left. thirteen years ago.
it was thirteen years ago. maybe fifteen.
i wonder if you remember.
this was when i came to be introduced to,
this One grain, sand of sand soil of soil
it was more real
than any real
more imaginary
than most imaginary.
i went with it each pocket, each stone,
each trouser cuff, each skirt hem, and shoe.
each eye where would be
tear caused
listening to stories carried by
this sand seed
heard by this One each place rested touched
 each person rested touched
is lost.
is never lost.

i still see the round sun drawn
just behind child head child arms
and beneath beneath one of which would be
this one particular grain would be
this one particular sand grain.

photo-essay

TRANSCRIPTION FROM A FRIEND'S MEMORY
ACCOUNTED WORD FOR WORD

When I was young, about four or five,
my parents owned this house, and the backyard was huge.
Maybe it was huge just because I was small.
It led down to a river (Shiawasee).
It had all different kinds of fruit trees and
in the center towards the house, there was a birdbath,
and around it were planted many tulips
all different colors in the circle about
twenty feet across.
And one day, during the summer, on the top of the river,
the fish were swimming on top of the water
hundreds of them. My friend Keithy and I we ran
to get our fishing poles and tried to catch them,
but they wouldn't bite.

LE BATEAU IVRE RESTAURANT, BERKELEY
7, DECEMBER 1977 5 O'CLOCK

we pretend
that she does not
exist that
we did not hear
her saying
i am sick
i am hungry starving
i want Russ to take care of me
and my brother is dying
and i am not thinking of Phillip
that's an old affair
she has a toothpick in her
mouth he leaves her
she is crying by the
candle light in front of the lace
draped windows
legs crossed
camel coat
she looks my way

ARRIVAL 31, AUGUST 1962 UNITED STATES OF AMERICA

The most astonishing
of the first day
was the abundance, wealth, the excess.
As a child, one imagined this "Gold Mountain"
as having no two treasures alike.
Instead, repetition became an inevitable
vocabulary member
Inexhaustible duplication self-regeneration
as necessity
This absolute wealth tyranny of objects
As force force of the machinery

systematic.
even with the image

even
desire

HIGH SCHOOL SEPTEMBER 1965 TO JUNE 1969

Frail, enveloped calm
single hand psalms on the organ
occasional clock bells, muffled cough,
clearing of the throat
announcing the ever slight human presence

Yet, the rigid obsessive order
skirts of measured lengths
interdiction of crossed knees, pearl earrings,
patent leather shoes, dances on campus,
frosted hair
single file synchronized gestures:
kneeling, opening and closing desks,
steps down to lunch, curtsy.
Primes, monday morning court processes,
medals and detentions, white gloves.

Reading D. H. Lawrence, Mary McCarthy, Henry Miller
inspite of. anyway. Later finding Norman O. Brown's
Love's Body in her bookshelf

But before then were dark halls, passages,
stairwells— turns beyond— to another realm
Moving shadows disappearing through divided screens
where once caught a glimpse
of a narrow white bed just fitted and a cross above

Faces veiled, layers of black habit floating with
their brisk two inches above ground and their
forbidden memory past

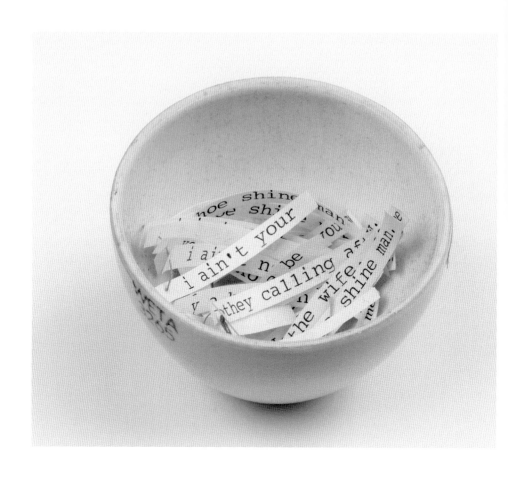

Surplus Novel

they calling me
they calling after me
hey yoko
hey yoko ono
yoko ono
yokoono
i ain't your
i ain't no I ain't
your yoko ono
i just want to
i just want
to be the wife
the wife of the
shoe shine man
shoe shine man
come dawn
come dusk
shine. shoe shine.
shine.
they all say
please. please.
take care of
yourself. yourself
baby, you are all
you got
i know. don't i know.
i just want to be
the wife. of the
shoe shine man.

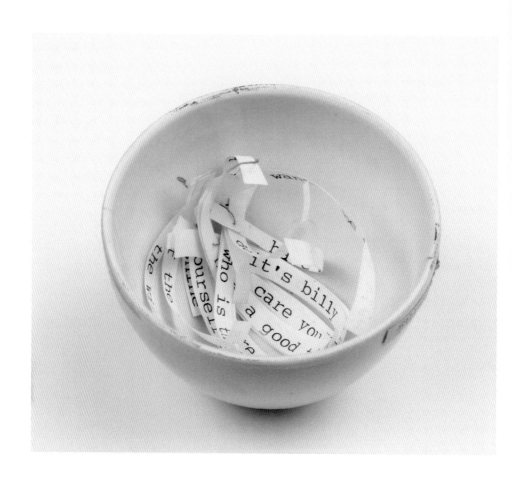

Surplus Novel

have a good time

do you wanna

it's billy

who is this

have a GOOD TIME

have a good time

do you wanna wanna

my name is billy

hi, it's billy

hi, it's billy

take care you

to take care you

but no one comes

yourself yourself

take care of

to take care

they all say

shine. shine. shine.

shine

shoe

shoe shine man

of the shoe shine

the wife of the

i want to be the wife

3

monologue
back and forth conversing

what if
i say
this
in saying that
for lack of a better word
for the heart of the matter is
that
if i should
say
none the less
in a way
in such a way
that would
that could
suggest
in other words
none less than
another possibility
an other way
one other possible way
only one way possible
the only other way possible
by that
meaning
it is already
said
being said
all along.

i have time.

banishment an insanity birth to history past present future
an offering an erasing the gum rubber scratching surface of document.
more pressure and more wearing to the tip until paper touches the metal.
an offering. to god the male white beard and flowing white hair robes
yards infinitum seated on a cloud attended by two maiden angels their
hair jet black in ropes twisted arches then the rest flowing likewise
with wind.
offering to god the male the old grandfather smiling and the cloud
not fixed it moves directions with wind.
an obsessive offering of the document the document of history
past present and future
i have time.
time links this hand to keys letters numbers signs codes symbols fantasies
secrets bald. bald to empty.
hollowed be thy name. hollowed be thy name thy absence thy remnant
thy gift thy presence. each act takes on masques robe of banishment from
the norm from the normal the adjusted the base structure support of the
pyramid or any box or fulcrum fulcrum of sanity.
urgency. sew up the ocean seams that makes time unholy with its indefi-
niteness its complacency its indifference
swallow the water one of the chinese brothers to save the other one that
may reduce ominous impenetrable binding
the violet mist hovering the cemeteries the tombstones in pinnacle to god
the father god the son god the holy spirit
the sins documented and erased the constant tides of recording and
erasing.
magic wand stick at its wave flying sparks make disappear this body into
another inside another with another from another into itself
its insides. organs. heart lung liver kidney
of course this time. banishment from present past to future
no sight the absolute link chain eyes to mouth voyage from eye to mouth
the secrets reinstated established bond traveling the inside face vein
stream from one mute to another mute tubes scribbled messages dots and
lines. keep faith no betrayal by either organ by holding ear to the other's
ear do hear what other hears?

sentiments 30 minuits dramas and 1 hour and a half movies for t.v.
resurrecting existences fish schools mounting and unmounting
character a to character b to character miscellaneous
ironing board. dishes. pots and pans. vegetables. bread. fruit. liquids.
the scattered alchemy of these materials. tide in and tide out.
recipe for salade niçoise.
copy of recipe.
dressing
herbes
time. marinade. serve immediately. cold or hot. how many servings.
four seasons road covered uncovered leaves budding or retracting inverse
process withdrawl committed communion of eye and mouth.
no eloquent thickness and volume no imbued purity
verse
blanketed rhythm spliced ebbings skinned and gutted will no prohibition
no interdiction from document scourge.
resistance to the cross. golgotha and gethsemane.
unattended sacrificial offering. three bowls before the image water
to the last bottom of the bowl floating dust and earth
fruits over ripe flowers yield to age over attended offering.
articles
 of reference :

birthmark stain folded page tucked inside back pocket
after washer and dryer cycle
pressed ivy greenish brown ivory outline border between two pages
yellow jacket cover book numbered no hesitance to prediction
the vocation the vow.

 the sky- sun's last yawn and the clouds bathed in sky not yet dark

 the clouds bathed the sun's last yawn. not yet dark, the blue still.
 this restaurant so frequented displaved by ✓ slight fever to another country
 sitting alone the child in a grey suit with the familiar haircut to all childhood
 counts the masks. xiiixxixx THE WORDS xxxixxxx ← cannot keep from their
 ominous watch over him so the talk gentleman would he be a writer, the father
 of the son and the mother with a brown felt hat one might see only the a
 japanese woman at ease in the incorporated FASHION of the western woman. Ⓐ
 would he be a writer like my uncle a poet, childrens poems and lyrics died
 of cancer his hair the grey on the pillow slightly turned away from me my
 last visit to him perhaps my only second one is he only a name now, is that
 all is left of him, his resemblance to his.my words to him,i no longer he was, but a catholic. but was in
 remember ↯ havinₛswallowed them they now in my veins they pound and linger the nurses were nuns
 as almost non-images as almost-images my words to him at same
 it's sunday and all the other sundays closer to the sundays further away
 than my memory takes my memory allows one w
 so as to savor the sundays more immediate in time bitter
 the breakfast with 2 english muffins:each one with butteredand/orange marmalade
 the other with butter and penut butter lapsang souchang tea heavy with
 cream orange juice and half a canteloupe puck
 if only if i could recreate if i could bask crawl beneathe white sheets when
 the sun was in my eyes the same swelling when on a BOAT to xxxxxxx
 familiar water the same swelling swept my head towards the photograph by
 habit it's night and but still the image DWELLING
 then this day this instrument of time this from systemitiaed dawn to mid
 morning to noon to afternoon to evening to night
 dusk
 this one turn this one sphere turning from one left position of body to one
 right position from lifting of the head to lowering the legs
 this brief holding of breath at the thought of how eternal this one day
 of sentence away from departure to xxxxixx gluing it is more difficult
 in foresight in anticipation of absence from present to looking at the
 future. and the future has come to be present to bear it to impregnate it
 as permanent shadowing
 and you think the inhale would never come you think youc an't continue
 you don't know what else there could be but you think you still can't continue
 you doN8t know how it can go on you don't know how it still does. you can't
 think behind that shortness of breath and from it comes this growth
 paralysis of the present. and you do,you do it rains and the beads on the
 leaves makes you the light on the whiteness of the wall makes you
 you lift the shade and agin the green plant faces towards the sun makes you
 and the bedding the sheets and pillows you consciosly or unconsciously make
 it fall you remake it over to resemble to imply its remains of the past
 to make frozen the past to bribe yourself to bring it to this present.
 the

 Ⓐ would she do all the cooking her delicate hands her delicate
 lifting of bottles + her delicate way of smelling its contents

 122

the sky—sun's last yawn and the clouds bathed in sky not yet dark

the clouds bathed the sun's last yawn. not yet dark, the blue still.
this restaurant so frequented displaced by slight fever to another country
sitting alone the child in grey suit with the familiar haircut to all childhood
counts the masks. cannot keep from their ominous watch over him. from
the walls the tall gentleman would he be a writer, the father of the son and
the mother with a brown felt hat one might see only a japanese woman at
ease in the incorporated fashion of the western woman. would she do all
the cooking her delicate hands her delicate lifting of bottles & her delicate
way of smelling its contents would he be a writer like my uncle poet,
children's poems and lyrics died of cancer the grey on the pillow slightly
turned away from me my last visit to him perhaps my only second one was
he a catholic the nurses were nuns is he only a name now, is that all is left
of him, his resemblance to his. my words to him. i no longer remember
having swallowed them now in my veins they pound and at same linger as
almost non-images as almost-images my words to him
it's sunday and all the other sundays closer to the sundays further away
than my memory takes my memory allows
so as to savor the sundays more immediate in time
the breakfast with 2 english muffins: each buttered and one with bitter
orange marmalade the other with peanut butter black tea heavy with cream
orange juice and half a cantaloupe
Sunday orchestra symphony downstairs its sentimental swell now
if only if i could recreate if i could bask crawl beneath white sheets when
the sun was in my eyes the same swelling when on a boat to familiar water
the same swelling my head towards the photograph by habit it's night and
but still the image dwelling
then this day this instrument of time this from systematized dawn to mid
morning to noon to afternoon to evening to night
 dusk
this one turn this one sphere turning from one left position of body to one
right position from lifting of the head to lowering the legs
this brief holding of breath at the thought of how eternal this one day
of sentence away from departure to gluing it is more difficult
in foresight in anticipation of absence from present to looking
at the future. and the future has come to be present to bear it to impregnate
it as permanent shadowing

and you think the inhale would never come you think you can't continue
you don't know what else there could be but you think you still can't
continue you don't know how it can go on you don't know how it still does.
you can't think behind that shortness of breath and from it comes this
growth paralysis of time. present. and you do, you do it rains and the
beads on the leaves make you the light on the whiteness of the wall makes
you makes you you lift the shade and again the green plant faces towards
the sun and the bedding the sheets and pillows you consciously or
unconsciously make it fall you remake it over to resemble to imply its
remains of the past to make frozen the past to bribe yourself to bring it
to this time present.
from the bed the bed to the plant to the letters. letters.
from the bed to the post office
from the bed the single pillow to the doubled pillow to the pillow on top of
another and finally from the bed to rain to traffic in rain to emerald shallow
tides encroaching an end the end emerald rain to a native husband to be
would be husband tall short cropped hair close to his head a dark suit brief
glimpse as he passed as he passed through hand holding the document
document of validation document of access entry size of one hand black to
heaven to hell
a photograph on the first page his credentials education. validated. date of
birth confirmed. parentage. verified. journalist. actor. catalogue of his roles
photographs still of his roles traditional warrior. savior. ghost spirit
revenging the evil. scenario. more stills. the shape of his back as he moved
across sunglasses perhaps
the shape of his back from behind to look again to turn and look again this
could be husband
 only with a phone call of validation of approval would one
 that one
suspect any contract the contract and agreement of marriage.
i would have stood up not counting the one to follow, three times to
rewind the tape to the same song to compete with the sound of this
typewriter. alibi alibi alibis
this is a book. i have an excuse. any excuse. all excuses. this is a book. its
length, its content, fiction or no fiction, is true.
is. is forgiven. is given the sacrament of penance.

in this room, the rain, the wind eastern in direction traveling beneath the skin layer purging the finality of dream and realto dreamlike to realike purging by thread by demon night illness

by chill the one greek column and mummified horse in galloping stance, buried in water, the re-burial, renaming, reclaiming, re-inscription of its anonymity. anonymity.

how do you manage? how can you tell the moment when the sickness leaves the body, the exact moment

leaving the yams in the oven for 3 hours. the black foam charcoal sweet smell crisp ashes.

it manages itself. condensation. evaporation. crystallization.

in the flask of a lung. the vapors. the dew. the mist.

the needle holes pin holes through heart wall the threads intersecting knots through the other end and the needle carefully removed

 not to tear. the sheath. the valves. tentacles. buds.

do they remember that one day the extension of an arm the speed rate of steps taken the volume of the wind the nearness of sea and tides a portal peep a victory a release a sigh at one single examination of a hand. only a matter of time. it was. it was time. already time tables.

this is my home. this is my knee. he said this in one breath. at least, there was no difference in value of these two things.

my home and my knee. it feels the same sharpness as this wind rising the empty rooms a low hum an echo.

would you read this would you read my book when it's finished if you understand the new york times the assassination article of your president would you understand this there is no subject there is no predicate there is no direct object there is no grammar there is no article. all the years you spent here all the literature courses you studied is this what they taught you i can't understand a thing my dictionary has no translation of this. this is the essay this is the fiction this is the poetry this is the novel this is the writing you have been waiting for. keep it covered say that it is strange that's enough enough for me. didn't you tell me not to read camus because the young students were committing suicide? didn't you tell me the young students were committing suicide. were you afraid. i already knew.

didn't you ask me why do you write only poems can't you write a novel an epic all the lovely lunches. cravings for a taste resemblance of childhood. two yellow tin boxes. one for breakfast and one for lunch. one bottle of either pickled cabbage an assortment of pickled vegetable. deep red. depending on the season. nothing oily about it nothing slimy to coat your stomach and nauseate you. cool, with cold white rice it went to the soul the essence of what we were. what we are. what we cannot change. the tin boxes wrapped in a handkerchief. one for breakfast, one for lunch. i watched my father in the mornings through the green closet doors, my mother's bedroom, earthen floor, yellow shellacked rice paper, the coals keep the heat the heat on your body on your back when you sit when you lie down. if it gets too hot, move to the backsideof the room, it's cooler. i watched the coal being changed. the round cylinder full of holes. the tongs to lift them in and out of the small door outside. a cremation. the grey ashes as remnants. my father, he kept some american candies. for the two last ones studying english at an american school. now i think they were milky ways they might as well have been to me i never tasted them until many years later. and maybe the small coated candy pills two lunch pails. he personally blessed them with cutting in half the ritual the candy the dividing halving doling out an apple each an apple keeps the doctor away an apple for the teacher, A the 1st letter of the alphabet how differently it tasted in america.

and the cat meowed and the dog bow wowed.

the two got off the bus the bus stopped they maybe they greeted me i was a maid i was the maid they came off the bus, across the street a small chinese restaurant they specialized in steamed dumplings i don't know where i got the money but they were very inexpensive we were silent i thought i was the big sister 10 or so we ate silently on benches. on a counter facing the wall. it was no major event no revelating reunion no love-filled gratitude

divine, pretend a scenario. a scene meeting at the bus stop sitting w/each other laughing, the tastiness of the dumplings, the hugs, the gratitude—the warmth of poverty. fulfillment of a sister role, as a member a recognition a place for this maid child.

after school i came home or was it saturday, we had school on saturdays i

came home we had a television. it did not work very well, but they watched
it. they had noodles ordered from a local restaurant. i watched them eat.
the maid. the sister. in the photographs. the documents
my father took me sometimes but never together with the others, i never
was dressed alike perhaps that's why there are no documents of my father
and i in the park eating and drinking and being a spectator. he took me out
once. we might have done the same thing. i had the same clothes. i
watched them on the weekend being fitted.
i ask myself do i resent it do i blame them this question so prevalent i don't
think so. the wound is deep, but precisely this wound this mark allows me
to see suffering and the need in others to be loved.
and my first and foremost need which is to love.
it is not difficult to remember, only pain. because of the wound,
but it is my calling. i have no other occupation, than to remember.

time between
it's times between feel urge to tell. hear.
and since last night for what reason
maybe because of the white
 because of the moment just before the extinction of an image
 extinguishing
maybe because our common denominator being
getting through

reading that george sand used to write several long letters each
day amounting 40,000 letters in 40 years
something about writing letters
one level single level writing, i hope you don't mind
giving a try at my own speed and length at a few words to you
what motivates. what it's worth
seeing and hearing you speak from x **fear from** x **want from** x **knowing
from** x **questions from** x **you as you from me** x **vice versa** x **to you.**
from why. from x **unknowing from** x **wanting to from** x **wanting to feel**
visual image sorrow discontent
from. starting from the very beginning at the middle, at nowhere end at the
present that is just is. what companion service could give to mend voids
how large how small.

my presence how could. could not fill lack would not exceed surpass
(it—object) (object of—sorrow. discontent. desire) or
my presence could would not exceed surpass. period. i cannot serve
through an image represented one then, from distance unnameable, from
proximity as air surround indeterminable proximity
(close to one's heart one would imagine. suppose

move
moving
moved

 with eyes, and all senses even 6th

hold
holding
held

 he foreigner friend
 (breath)

if you could know

 je pense à toi si souvent trop peut-être

if i could say
i only know so well that it is exactly this. attempted disinheritance
neither am i intellectual nor ascetically disciplined dicipled

as i wander sadly gladly full i wake je t'appelle. ton nom.
name. a strand thread it follows aim less but so totally

our common denominator being getting through getting through barrière
which named in la jetée the jetty un homme marqué par un image de son
enfance image de son propre mort

 12, Avril

lament i lament your youth

 your youth you

 blind un know now n

 to you

 un seen to you

 un to you un seen able

 un see a ble

 un say

 a b l e

 to you

 for lack

 lack of a word

 a better

 word woe

 foe

 dye, cast dye caste

 separation

 par/

 casteaway

lying lain having laid lain gesture lame foundation founded
what for - for what + (cause, development, effect) =
airing
amend
i amend
i adjourn
to day further later far in advance aside extend
through "exorcism" esprit manque disappear even further!
je ne veux plus veux plus du tout vient la fin le dernier mot.
enfin, tu es venu finalement

 all come together

 16, Avril

trip

many letters i have written many poems in them how many
how much full each time felt love l o v e so. and . . .
much full tear t e a r heart h e a r t so. and . . .
full not able to speak s p e a k as burst b u r s t i n g
almost a l m o s t and . . .
what desire d e s i r e only interpreted through one being able
to receive and re call r e c a l l re name r e n a m e
and who w h o trip will could hear me m e . . . say so say so.
open my body open open my heart open banal words over used and
soiled but, but . . . still s t i l l not so. n o t s o a t a l l
a t a l l. sorrow i cannot mend sorrow you y o u in you
i want to. i want to w a n t to

many l e t t e r s i have written many p o e m s in them t h e m
how many m a n y how m u c h full each time felt l o v e so.
and . . . much f u l l tear t e a r heart h e a r t so. and . . .
full not able to speak s p e a k as burst b u r,s t i n g
almost a l m o s t and . . .
what w h a t desire d e s i r e only interpreted through one
being one being able to, receive. and re c a l l re n a m e re
and who w h o will c o u l d hear me m e . . . say so say s o .
o p e n . open my body open o p e n my heart open banal words
over used and soiled but, b u t . . . still s t i l l not so. n o t s o a t
a l l a t a l l. sorrow s o r r o w i. cannot mend sorrow y o u i n
y o u i w a n t t o. i want to w a n t t o i said so d i d.

16, Avril

18, avril
today
cry i want to not only
becoming god i am not a saint too much water wallow swallow 제비

where do you come from soon to leave again leaving again
will carry this to where you go carry this heaviness enough to touch
bottom in light in air will carry to who will hear see hold and none
the less none less than
i know. i know that this all weigh in the middle in the center
and opposite rise together i think it might be snowing
forever will i be denied
question.
monologue. back and forth conversing

récit

reciting a poem

re citing a poem

re sighting a poem

re insighting a poem

 citing to move to action, instigate, rouse

 on the ground locations inscribe and cover up

 re locating the poem

 and covering it up again

flour, plaster

 amsterdam

 piece for hreinn and hlif

 june 1976

the sound is a dripping faucet, ticking clock, someone's television set.
electric currency, a towel hanging on clothes' line, bottled water shivering.

outside this building, sun must be falling, outside the notre dame
the light already reflecting on the river: on montmartre the myth yet
creating another fiction perhaps that is what mean to be collective,
universal, paintings of clowns that destroy time and space barriers. it could
be another country, still. could not deny the sacré coeur, the abbaye.
looking facing us. looking against and before us. looking behind us as we
look, the same direction.

entering hotel st. james. friends are doing figuration for a film el cid
building in ruins. last year, at marienbad. mirrors, long corridors marble
columns.

the sound is a police car. church bell. seeing for the first time the
tableaux of puvis de chavannes. charles baudelair

beaudel'air

baudelare

sound of unpredicted rain in montparnasse cemetery. sitting by the tomb
of tristan tzara, i wonder who has brought the flowers.

gardens above ground, to be only seen and admired long rectangular
promenades as rigid as rows of hallwaysentrances
the africans coming from the mosque in robes carrying wind colors
draped flowing their head dresses and not a drop of sweat clouds

the sound is rolling stones' nth album in the loft tania mouraud.
experience of the objectseenby thesubject

paris
22 june 1976

i have taken a bite of this root
pockets on paper openings on paper
black screens

as for the rest, trembling trembling a hole in the sky

by yielding
it would be

by yielding
it would be

a long waited
impossibility
too

quiet phantom

súm art does not go into the monumental in art, but searches for
the petites choses, the primal movement, the flickering of light. it looks
for the roots of the language before it is born on the tip of the tongue, it
goes toward the thing before it can be turned into a sculpture. color is
accepted only while it has not yet become some special kind of colour. in
music it is the sound before it becomes a score, music, or a symphony.
literature is sometimes only the page before it turns into a written page in a
book. súm-art makes, so to speak, an effort to create a
retrogressive evolution.
 it is the spiritual in colour icelandic wisdom of eccentricity penetrates a
súm art that extra ordinary individual and only wisdom known in iceland,
the wisdom of isolation, of the individual outlawed human being.

hreinn's piece

i spend the day with the sun i spend the night with moon and stars

reflection on creation
creation being not just a mirror image. it is this, and at the same time
that so it is both

a vow somewhere between this word w o r d

avow just before the word begins

avoue even before the word begins just

 before this w o r d ends some

 where some

 time

 before this word said

 this w o r d written

 word suspension

 the last breath taken before uttered

 before sound formed the gest

 before the instrument sounded

 and it is not THIS word.

the sound before it reaches ears

 when it leaves us

 before wind becomes felt

 and not end there. and end there.

 hesitantly before an act made

 hesitance. yet made.

 effort energy taken before act made

 yet made.

 and after accepting the passing—

 as it passes takes touch elsewhere

 taken from elsewhere. holding my breath

trying not to try to not try to try to to try not not to hold back my palm

could only open all the heart to burst az rain az thunder always this another time

bearing over am doing

one folding in another folding in one in another folding
fusion . . . dispersion
stagnant lac brûme le matin brû me le soir and hold and rock let enter
contained statue
 coiled up eat from the end
 devour
 back to the beginning
 eat its way out of it
 through it
 into it
 back from it figure eight

 amsterdam
 28 june 1976

```
fly   by   night   fly   by   night    fly by   night   fly  b
y   night   fly   by   nig ht   fly   by   night    fly   by  ni
ght    fly   by   night   fly   by   night  fly   by   night
fly   fly   by   by   night   night   fly  fly   by   by   nig
ht   night   fly   by   night   fly   by   by   night   by   ni
ght    flynight   by   night   byflyby   night   by   nigh
t   fly   by   night   night   fly by   night
```

i wanted to wrtie write something before i become too sleep y. everything change
in relation to. something else. like these margins. these lines that divide the
paper into se ctions. too sleep

KYUNG

view from the willow tree paris

sound: sound of plane
 train
 walking on gravel real noises letters typed on paper
 keys a few sounding

i return ed came back climb down from the tree
closing the book to open some time later
she said, "i missed you times crying over your feet" (. . .)
i dream ed there, back on empty road three
 she sitting over ledge of staircase a book in hand
i think ed change trans form grammaire
 vocabulaire
 speak tongue
 minimally mini teeny tiny tintsy
 tintzy

i feel felt wind breeze clouds over ireland
spewed from the mouth of some enormous god
with enormous mouth traveling backwards
ecume

green canal drifting elm leaves t
 h
 i
 s
 y a
 w

houses leaning on each other

 lately

 referme
kisses on the mouth some kind of miracles
how will a child be seduced in any case seduced
how will a christ be seduced in any case seduced by gentility
a marginal seduction some king's wish
on the mouth of some théorème

For my brother

He said
 His Mother
Comes from the Lake
He said
 His Father
Comes from the Lake
He said
 His People
He said
 Their Name
 His People
 His Name
He asks
 Has any Man
 spoken for you
 Woman?
He answers
 no Woman has spoken
 for me
This Indian spoke
 this way
of His Origin
 From the Lake

long interval of silences

intervals

so, this was how it was meant

meant to be

for now.

i wonder if you have seen met tim—tell him i saw his garden yesterday

christo's running fence all over landskywhite hypnotic
ocean roads long some place i sat wandering over water's moving

today the morning light filter mould around skin harden melt

^The attempt here is to accentuate the off space of the paper. the space
that is naturally often taken for granted

^Here, by marking as line drawn accentuate the negative space. the
opposition that brings forth the once absent. state the presence of the absent.

^Exit. determining of the receptive space interlocking of an action on a neuter
stagnant area becoming active by the marking

^Missing within a totality itself missing inseparable from the totality only once
put on backwards as would with film, would it be possible to mark where

^Indeterminable space without any quality or quantity of its own illimitable
without the act of putting on a line there is no identification of this space

S
 possibility of creating tension in this space and perhaps in union with
 it the force of the entrance of the other

S

I

N

G

P

A

G

E

11.78

writing conscious-unconsciously. in delirium it's fiction. its fiction
from left hand corner to the right hand corner. from left to right.
what abound. n' importe quoi. mere it said. sea and boundary.
wall dividing. sea and boundary. fingering through and through.
some absent touch bound to be somewhere. a new line curve a page
a possible chapter. it's unseen. as soon as it is invisible
as soon as. retaliation. retreat. into. excerpts. pittlings.
pittance here and there scattered ashes bits towed by wind invisible.
esclave vagabond
preference partiality identity sauvage.
identity preference
partial to identity preference
partial to savage identity preside. nausea
reminds me of cold cream mayonnaise oil floating now in my stomach
my father my mother my brothers my sisters anger where there is
compassion and pity anger to hide all too well known love what else
could it be. bumping over tumbling into and out of
silence crave chasm
butcher sign smoldering **cause for disembodiment**
cause for restoration one less mouth to feed
unless
and that one time somewhere i had understood something
how an h follows the t in 'the.!
"just to keep the void out" how many times how much what else
just to keep the void out. to call something else in the name of
just to keep the void out. was it false was it called false
only it was true but called something else just hidden that's all
for the time being until ghosts leak or dragged out again one by one
even not knowing it until too late
in moment of passion too easily flicker and wane
each death more severe more cripple into a dark
meeting ground suspended not knowing what to admit or to hide
grumble and turn away
again say so, say so. come and say so, just to keep the void out.
ner never would he have traveled never will he never would he

4

White Dust from Mongolia

Introduction

CONSTANCE M. LEWALLEN

In late 1980 Cha and her younger brother, James, traveled to Seoul, South Korea, with the intention of making *White Dust from Mongolia*, a film Cha had sketched out in detail and for which James was to be the cinematographer. Cha had received a grant of $3,000 from the National Endowment for the Arts and a $15,000 Chancellor's Postdoctoral Fellowship from the University of California specifically for the film. They arrived in Korea during a period of political crisis. Martial law was in effect following the assassination of President Park Chung Hee the previous year. As Theresa and James tried to film in the streets of Seoul, they were harassed by the police and were finally forced to abandon the project.

We have included in this section four stills extracted from the short segment of film James Cha did manage to shoot while he and Theresa were in Korea. These tantalizingly suggest what might have been. The description of the project Cha wrote earlier in 1980, before her trip, indicates that she was intending to make a feature-length film of approximately 100 minutes, her most ambitious film to date, in which she would develop issues that had appeared in earlier works. In her application for funding from the National Endowment for the Arts, she described these as "going back to a lost time and space, always in the imaginary," adding, "The content of my work has been the realization of the imprint, the inscription etched from the experience of leaving, the experience of America." Characteristically, Cha carefully mapped out each scene, as the storyboard pages included here make clear. Also included here are several short poems that appear to have been written by the artist during the planning process for the film, which we found in the folder that contained the preparatory materials for *White Dust*. Once back in New York, she planned to reimagine *White Dust* as a historical novel. Because this was to be such a major work and one that indicates a future direction, it seemed important to include it in these pages, even in its unfinished state.

White Dust from Mongolia

Project Description

The film is a simultaneous account of a narrative, beginning at two separate points in Time. The two points function almost as two distinct narratives, the "Times" overlap during the diagesis of the film, and a final conversion of the two points is achieved to one complete superimposition, to one point in Time.

Narrative I begins in the Past, within the interior of memory itself. The memory materializes physically on the screen (film projected on the screen is the memory projected—the viewer "sees" physically the memory images). Film/Dream—projection of unconscious images. The film starts within the Interior of the mind of Character #1, as she begins to "see," begins to "remember" the latent images/memory just before she is completely "cured" of amnesia.

Her identity is established in a missing persons column with her photo. It is the establishing, marking of an absence, and a search by equally anonymous persons of no specific relation or consequence to the missing person.

She is without a Past, her past is speculative, fictitious, or imagined. The narrative alludes to abandonment, war, orphanage, her absolute anonymity— encompassing her disappearance, her abandonment, and finally her lack of memory, and lack of speech (amnesia, verbal amnesia). Her anonymity gives the character a possibility of multiple identities, she becomes "collective," a metaphor for any possible identities:

–young girl at the cinema
–maid crouching on the ground, her back turned
–merchant woman on ferry
–marketplace
–orphan
–nation, a historical condition, Mother, Memory

She is "given" identity as she is "found," as she enters the process of being "cured" of amnesia. She is given a new set of vocabulary, a new language, an Invented language. She is told her name, many other names, events and

locations of her assumed Past, she is literally taught the alphabet. The introduction of Language, (foreign), the extra-identity, or new identity, qualifies the rupture, displacement, both physical and psychological.

There exists a "Hole" in Time, a break in the linearity of Time and Space, and that empty space, the Absence, becomes the fixation, the marking that is the object of retrieval, a constant point of reference, identification, naming, the point of convergence for the narratives, the point of rupture, which gives, considers the multiplicity of the narrative, multiplicity of chronology.

Narrative II begins in the Present, with the Telling and Relaying process of the "Récit"—It is the process of Défilement même du récit. (Self-reference-film, narrative structures, language, memory in relation to each.)

Character #2 is at the moment of the return, to retrieve events past (marked within the chronology of Time, which functions as punctuation, as marked points in Time). The return re-marks the locations, points in memory, re-peats the Past sequences.

The actual physical movement backwards in Time (voyage, Time change, territorial divisions, etc.) is relayed always in the Present Tense. Each meaning, sign of Passage is catalogued accordingly: war immigration, foreign immigration, "trans-migration" of memory, of imagery, of language, of identity.

The narratives begin to superimpose, the separate Times in chronology converge at the point of "destination," as it is becoming redefined (from Memory) the locations, events, as they correspond physically with those within the Memory.

—It is Character #2 who returns, gives memory to Character #1, #2 is the retriever (the activator) of the memory of the narrative by the process of recounting the Récit.

—#2 is the voice for #1.

—#2 and #1 are the same, become the same.

—#1 is the memory for #2.

—#1 is the spectre memory, imagination (decaying sense) of #2.

—#2 is one who searches #1.

VOICES CHARACTERS

#1 Within the mind of Narrator #1 — amnesiac when she begins to remember
 (the voice of Memory itself)

#2 In the first person only (?)
 In the present tense only
 Voice giving Memory Voice teaching Language

#A Documentary voice, indifferent voice of announcer, as marking
 as punctuation to the film — within the diagesis of film
 a Korean voice
 b Translator into English
 c Voice giving identity: voice of interrogation
 enforcement of identity
 repeating same material as the voice that teaches, gives
 speech and memory

1. Within the interior of memory itself, within the mind of woman #1.
 The images are physicalized, materialized on screen, film projected on screen is the Memory projected. One sees, physically, the memory, the "sense," or the decaying sense.
 Speaking to herself under breath, faint images, resemblance of images fade in and out, from/to white at different duration at different clarity. Very sparse shots, of abandoned quality.

 −barren road—still frame
 −empty tracks
 −cinema billboard
 −marketplace
 −plane runway—still frame, or plane barely buoyant, low to the ground, dreamlike—slow motion if possible
 −room (empty)

2. Photo and article in missing persons column
 Date of article
 Name of missing person
 Missing date
 Brief description of circumstances in which she disappears (possibly the conditions—her mental state—amnesia and verbal amnesia)
 Contact—name/address

3. Airplane body parts intercut with "body" of landscape of Korea (possible one pan right to left on plane and one pan right left on landscapes same slow speed and either cuts or dissolves on panning movement—so each landscape shot in panning motion).
 Dissolve with landscapes and plane shots, mother's hands, (CLS) father's hands, folded on the knee with dark background, only hands are visible.

4. Position, object match-cut to hands folded, holding a child on a woman's back (CLS). Cut to MS of woman with child from back.
 This shot is highly stylized, choreographed, in sparse room with one black line going across the frame and a sign indicating the partitioning of space/territory.

A soldier, Caucasian, body facing camera, face in profile, spraying DDT on the woman at the crossing.

5. Dissolve to white.

6. From white to CLS of queue (line) of people waiting—zoom out until the borders of the photo/poster on wall of people waiting with canteens for rations from the U.S. government.

7. One room, the same room is used throughout the film as a kind of punctuation and metaphor.
 Diagonal shot? (still frame)

8. Orphanage/abandon shot
 The same room/photo of orphans on photo poster (ask Maria for photo)

9. Crowd scenes (Korea—location/sound)
 –airport
 –marketplace
 –cinema lines—same movie house as before (sequence #1)
 –merchants on ferry
 –streets
 –cinema lines—same movie house as before (sequence #1)
 Camera handheld at parts following crowd (identification of eye and camera—the one behind the camera is the one who looks, in search her memory).

10. Empty railroad tracks—woman enters frame left (same shot as sequence #1).
 3/4 profile, back to camera, she waits, she is waiting, possibly looking for someone, or is about to leave on a train.

11. Same room, rear projection screen.
 Same room with the black line going across the wall behind.
 There are two chairs, a translucent bulb hanging from the ceiling and a gauze curtain in between the chairs that face each other
 (this is the shot with the interrogation).

12. Same room, without the black line—same layout (shot with the teacher, the one who gives speech/memory).
 shots

13. Series of partitioning of space to emphasize the dual exchange dis-course, dialectical structure, binary structure of language, trans-movement from one to the next (memory as action—only language can construct it [memory, action]—imagination equated to speech is the same . . . etc.).
 –close-up shots of two faces in shadow projection from above, having the curtain divides the space in half vertically
 –a straight shot slightly at diagonal where the figures almost overlap, the curtain divides the space horizontally
 –a complete diagonal shot

14. As two women continue their exchange (the partition of gauze curtain removed?) and the shadow projection is changed: the figures are seen without the silhouettes, there is no camouflaging. Images begin to appear behind the two figures, and gradually the women fade out and only the images are left.
 –the image becomes larger (CLS to the image projected)
 –larger still until the image takes over the whole room—Memory, projection takes over completely, the complete transference—trans-immigration of image and memory
 –portraits in studio windows—Busan
 –airplane
 –railroad tracks
 –inside the train
 –family photo genealogy
 in/out of white of single images until two images simultaneously superimpose and become one image*

16. Actual marking of places remembered from the Past.
 Sequence of returning to those locations and points:
 the actual points and the speculated points.

* Editor's note: In this list, Cha's numbering jumps from 14 to 16. A blank space was left between items 14 and 16; perhaps she intended to add item 15 later.

−street where we lived

−roads behind Seoul house

−Busan

−Song-Do (on boat)—photographs of dad and kids, at the beach,
 family photo in Busan

−the ferry leaving Busan

17. The cinema
 Empty screen, empty theatre with rows of seats.

18. The woman-child seen inside the theatre, standing in the aisle.

19. On the screen is projected same shot of railroad tracks.

20. The woman enters live from screen left, stands before the tracks,
 her back toward camera 3/4.

21. She walks into the image slowly (shadow larger because she is
 standing farther away from the screen, and becomes increasingly
 smaller as she moves closer to the screen).
 The image behind dissolves from CLS to MS to LS (axis).
 She physically enters the image.

22. Fade to white

23. Image of the same room projected on the screen.
 The camera tracks back, revealing the screen periphery,
 revealing the room in which the image is projected.
 (Multiple axis of images—echoing physical and metaphysical
 entrances/exits memory/image/language.)

White Dust from Mongolia

Related Poems and Journal Entries

by train going to school by train through dark tunnels the smoke comes
in if the window is not closed everyone screams when the tunnel comes
everyone says the tunnel is coming two index fingers in each ear
pressing so hard as the dark as the tunnel all the older girls protecting
going to school by train one hour it takes always late for school

could not bear to say could not

could not bear at all all bear it to this to say
to this to this

it would not have to come to this to be able to be
said unbearable either to say not to say

perhaps hands should before mouth could move perhaps
whole body limb to limb before starting again to be
torn before would have to say ever again perhaps head
eyes derobed blinded before it is necessary to say again
to speak to utter to tongue even to tongue even to
mouth

without a single sound without a single voice
removed broken tied irreparable

there is no wind to carry
 vow to muteness
for words to be inconceivable.

plumage flowering pilgrim vigilant to history. ancient ancient
not even dwindled to this day.
broken pulled and severed this act a perpetual breaking a perpetual pulling
perpetual severing from ancient history the history that lives that is
giving color to the skin excretes from pores cleanses and dirties from 0 to
infinity then
 rebirths and destroys the present
the absolute present. abolishing sins sins never committed
only a response to sin committed to me to i to it to childhood to being
in turn is now called sin

missed delayed
target having met it not recognized it as being
 he dismisses me
 each small thing becomes larger and larger
 he shows in front of me the very object
 which represents the act of outcast
 of denial of duty only duty free
if that is not repetition

i forget i have forgotten in the beginning i am trying it has been proven
that i have recovered some amount of my memory. it was indicated to me,
more than once. it was more than indicated, it was assured to me
you can now remember you have made progress your amnesia begins to
disappear. i remember that much. at least. she tells me i have a memory
all that i have forgotten only manifests in another form
manifests in another form in the future affects the future

person has amnesia. marked by one strong incident—that of being left
airport
train station
buses

you would see this woman at these places. elle attend elle attend enfin, le
retour de son souvenir. voices: of the person seeing her, following her, and
the one who is being followed, their voices mix, the one
who follows eventually is her. or something like their relationship becomes

single. one cannot separate the two voices. mother/sister/self
perhaps in seeing this woman who has amnesia, she recalls her own
memory is attracted to her
and the woman is also dumb—she cannot speak the speech is coming
from (elsewhere) sanity/insanity
question of wanting to/not wanting to remember

comment de dire
how to say de dire comment dire how should one say how say how said
comment on pourrai dire how could one say
this
c'est ça this this is it the way this is the way how said
the way done how be said how done
comment c'est dite comme comme
how like like how
like that is to say—c'est à dire
this it's here
could not bear to say it could not
could not bear it at all bear it to this to say to this to this
it would not have to come to this to be able to be said
unbearable either to say or not to say
perhaps her hands should before her mouth could move
perhaps her whole body limb to limb before starting again to be
torn before she would have to say ever again perhaps her head
her eyes derobed blinded before it is necessary to say again
to speak to utter to tongue even to tongue to mouth
(madness) without a single sound without a single voice
he/she removed broken tied irreparable
there is no wind no wind to carry
she would vow to muteness
for words to be inconceivable
i am her body i am her flesh inevitably conceived each other through
and through there is no denying no reparation
when everything else forgotten needless fallen away
should one go to god for memory should one go to god for speech
to god for the words forgotten thrown to god because
he speaks without gestures without alphabets without meaning
because to god i would conceive him his thought his sorrow as mine
without words his tears without knowing that they were his
because she never said anything and i understood it was already
known knowledge
because she never waited she has not waited

i look
at her
i am before her
i know her who she is i used to
i don't
know her i never knew her
after all
i don't remember
her anymore

i

you

he

she

intertitles it

we

they

them

she knows she knows well very
i don't remember anymore
i don't even know that that i don't
no memory
i cannot speak i don't know
the story
the first time the beginning
the very first time it was, it must have been . . .
the very first the very beginning
when i saw her sitting on a bench at the train station

i stop i am behind her
i follow
from a far.
at times i am very near.
i approach.
i stop. for some time. awhile.
i don't know if i should continue. if i should go on.
if i should not leave. turn my back and leave go back.
i stop for sometime.
i look at the ground.
i turn; even in turning i already know i will turn back again
i turn again. return. i follow. i am behind her
she has told me already to stay. stay at home.
each time.
i stand at the gate
just to the door
i watch her
a few steps before me
she might turn her head once

one day she was leaving. all the preparations forever managing still
to continue. she dressed differently, in suits two piece or one piece
dresses. enigmatic these words so spoken one piece two piece

observing her no longer recognizing our tie, only reminiscent of a tie
always on a verge of a tie verge of yearning so far so far that country
on the verge

and she was leaving. leaving for america beyond here, besides this.
everything else was america. without borders. today. some glimpses of
her amidst crowds surrounding her.

at the airport what was an airport women dressed in uniforms grey
waiting eternal looking down from the balcony below the passengers
leave was she among them 1961 a woman and man the man korean the
woman
any other than korean would have been american she with a child
she her expression she cannot say she leans she tries to lean
child with her he mutely makes distance his face with no expression
she says something she walks a few steps towards he might have kissed
her she tries to stay further towards he leaves. short.
he might have turned his face and she her face her expression
how rare to see her then her short yellow hair and public her open
lifted her face standing

my mother her head bowed as my father tides words until last minuit
photographs as she held on to her youngest and she left. my mother.
vast landscape the airfield so far she waves. she might have hugged
me before i could even know did i have a speech for her she left
so often before i knew
one plane one woman in her grey uniform at the door and my mother's
sister next to me

history. it is history anyway. ancient. in any way in whatever way in whichever

not long. ancient. just.

i follow her. to the train. to the train station. always leaving. and the time before that, the last time. once again one more time and let that be the last.

she would have nothing. nothing changed. nothing would have.

a few days. only a few days because by now it's ancient history.

 before then, indeterminable. infinite. never.

at last.

except for the witnesses witnessing and the vigilance and the marking of eleven years births.

i am seven. and my sister, one. it's midday. summer.

she was just there with the others. her friends. the women.

i carry her always. she doesn't cry.

in front of the bookstore at the corner she took me there several times.

walls of books ten times taller than me. bound all white with black lettering.

she is not there inside and ask the lady. she has left.

she thinks she has gone to another friend's house. she tells me where. i tell her we are going to look for her. walk a long time

 step over the gate and wander might have called her.

a woman comes she tells me she is not here. either.

 don't know where else. on some narrow streets a long time

she is quiet. maybe she is looking too. on the main street again. buses.

almost home. and i she sees me where was i tell her

looking for her she asks me why

image sans son
son sans image
image sans text
text sans image

within the mind of narrator #1—amnesiac when she begins to remember
speaking to herself under breath appear before her the faint images
semblable very faint fade in and out at different duration at different clarity

> away from her
> all this time
> have lost
> her tongue her own
> own tongue my own
> no recognition
> she has no recognition
> none
> abandoned her
> abandoned

punctuated with shots' duration as markings (locating points in memory)
without people, empty shots very sparse, abandoned
fading from/to white

within the memory inside the memory itself

narrator #2—in diff/voice documentary voice (no relation to amnesiac—)
one voice in korean reading the article—the other voice translating into
english—superimposed two voices with slight delay.
background history—the person—anonymous female
 the context—disappearance/event, the "story"

narrator #3—in first person one who has seen her who finds her
 enunciator from her memory

inside memory/image of the amnesiac
memory of the observer—possibly some relation to the woman
amnesiac-daughter relationship is somewhat undefined—psychiatrist?
social worker?
it is she who re-teaches through Language, or to regain memory—or
another set of events, another set of new realities that might not even
really pertain to this person at all. left ambivalent. fiction—multiple
narratives
multiple text—memory as text—replaceable by another set of fictions.

non-linear chronology—in memory, the set of events remembered are not
necessarily linear.

IMAGE	SHOT DESCRIPTION	SHOT	DURATION
25.	25. TO THREE WINDOWS OF PLANE	EX.CLS	
		STILL FR.	
26.	26. DISSOLVE TO 1ST PAIR OF HANDS.(FATHER)	EX.CLS	
		STILL FR	
27.	27. DISSOLVE TO ONE SINGLE WINDOW	EX.CLS	
		STILL FR	
28.	28. DISSOLVE TO 2ND PAIR OF HANDS (MOTHER) CUT		
29.	29. WOMAN'S HANDS BEHIND HER BACK CARRYING CHILD	STILL FR EX.CLS TILT UP	
	CUT	STILL FR	
29.	29. MCLS OF WOMAN	CLS/MS	
	CUT	STILL FR	
30.	30. ♀ BACK TO CAMERA MALE SOLDIER BODY FACING FRONT HEAD PROFILE SPRAYING DDT ON ♀ AT DIE	LS TILT UP	
		STILL FR	
31.	31. FADE TO WHITE		

Pages from the storyboard for *White Dust from Mongolia*, 1980.

IMAGE	SHOT DESCRIPTION	SHOT	DURATION
32.	32. FADE IN FROM WHITE TO QUEUE OF PEOPLE WAITING - ZOOM OUT UNTIL THE BORDERS OF THE PHOTO/POSTER ON WALL OF PEOPLE W/CANTEENS FOR RATIONS (BACKS TOWARD CAMERA)	CLS → LS	
33.	33. VERY SLOW ZOOM OUT/TRACK BACK ? DISSOLVE	LS.	
34.	34. TO SAME ROOM SAME AS SHOT #16 CUT		
35.	35. PHOTO OF YOUNG GIRLS (ORPHANAGE) ZOOM OUT AS SHOT #32-33 (VERY SLOW)	CLS zoom or track back	
36.	36. UNTIL BORDERS ARE SHOWING OF THE PHOTO PANEL CUT	MLS	
37.	37. ON TRACKING BACK FROM CAR ON STREET (VERY CROWDED) (HOMAGE À RENAIS) SEOUL MAIN STREET CUT	TRACKING BACK SHOT	
38. GATE 1 GATE 2 GATE 3	38. CROWD SCENE AT AIRPORT HAND HELD CAMERA MOVING THRU CROWD FOCUS ON ♀ CUT	MS	
39.	39. MARKET PLACE SHOT #12 EXCEPT VERY CROWDED HAND HELD CAMERA MOVING THRU CROWD FOCUS ON ♀ CUT	MS	

IMAGE	SHOT DESCR.	SHOT	DURATION
40	40 MERCHANTS ON FERRY ♀ W/ BUNDLES REFUGEE SCENES CUT		
41	41. STREETS IN BUSAN (FROM BUS) CUT	TRACKING SHOT	
42	42. CINEMA LINES - SAME MOVIE HOUSE AS SHOT # 11 HAND HELD CAMERA NEXT TO LINE LOOKING FOR ♀ CUT		
43	43 EMPTY RAILROAD TRACKS SAME SHOT AS #10	LS	
		STILL FR	
44	44 WOMAN ENTERS FRAME LEFT STANDS. 3/4 PROFILE BACK TO CAMERA DISSOLVE	LS	
		STILL FR	
45	45. ROOM- SAME ROOM CUT	LS	
46	46. SAME ROOM WITH BLACK LINE ACROSS - ALL IN SILHOUETTES INTERROGATION CUT	LS	
47	SAME ROOM W/OUT BLACK LINE SILHOUETTES MEMORY RETRIEVAL CUT	LS	

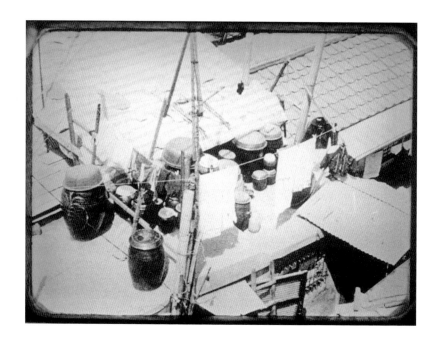

Film stills from *White Dust from Mongolia*, 1980.

5

Faire Part

177

.une....

it is almost that

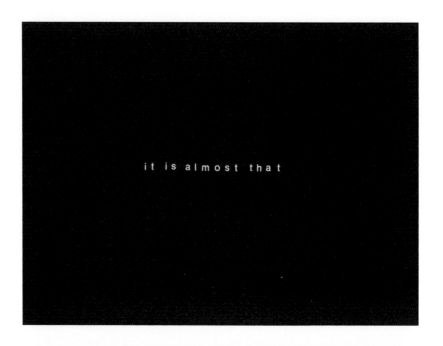

it is almost that

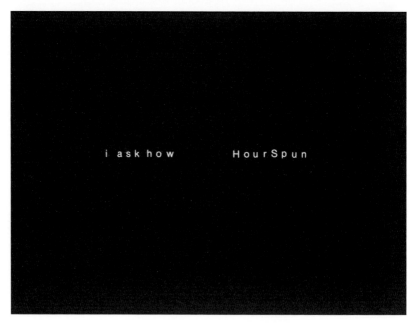

i ask how HourSpun

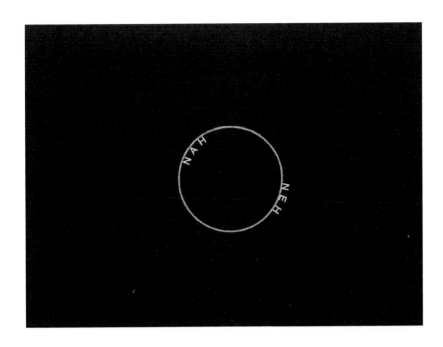

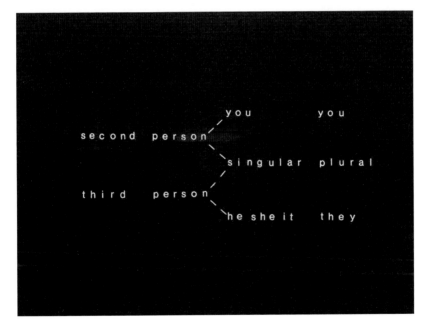

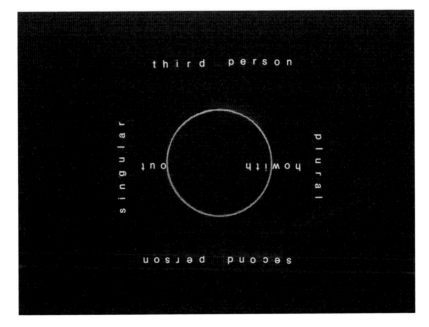

saw one.
received two.
mouthed three.
imagined four.

and then
i would say
it is all the same

to me.

and so,

me too.

i would admit them.

stated.

as personal. as
narration

plural

Commentaire

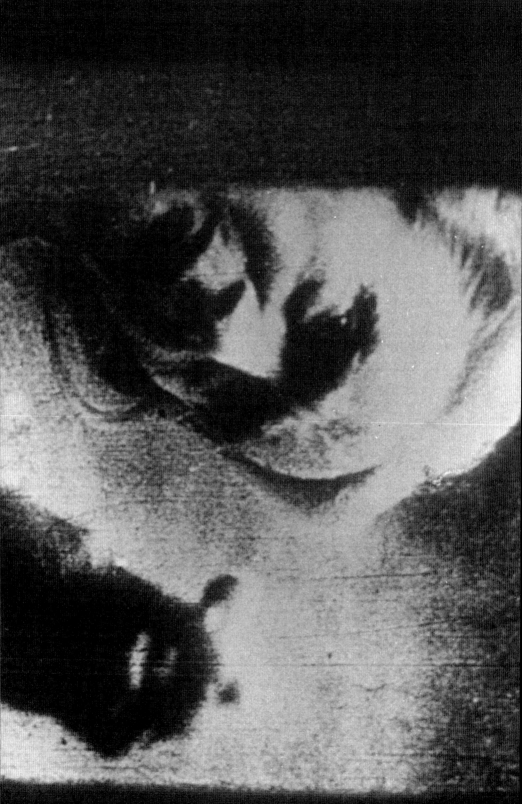

COMMENTAIRE

noir

COMMENT

TAIRE

blanc

COMME

COMMENT

COMMENT TAIRE

TEAR

ECRAN

SUR

ECRAN

blancheur

COMMENTARY

AS, LIKE

HOW

blanchir

HOW TO

SILENCE

blanchiment

TO TEAR

noirceur

SCREEN

ON SCREEN

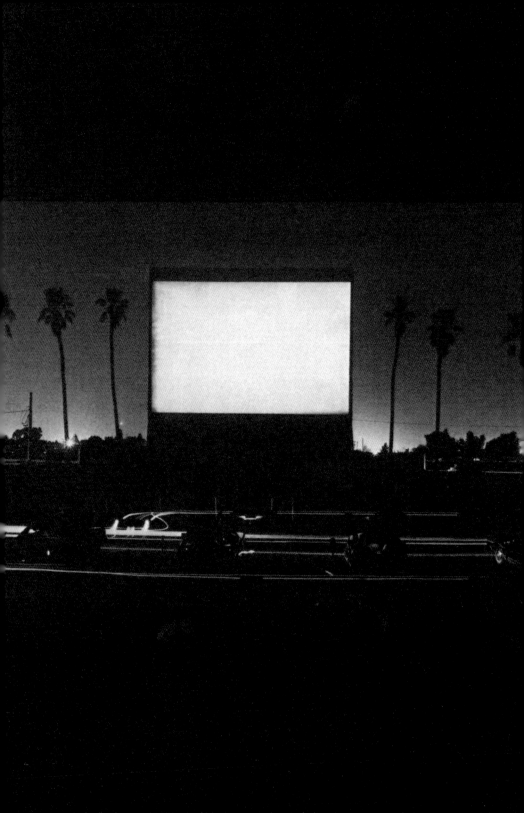

WENT

PAST

MINUTE

OR

MOMENT

ARILY .

blanchissement

COMMENT

TAIRE

MINUTE

BY

MINUTE

TO

MINUTE

OR

TWO

HOLD

TONGUE

HOLD

noircir

TO

ONE

MORE

noircissure

AND MORE

TIME

TAKES

TO

HUSH

—

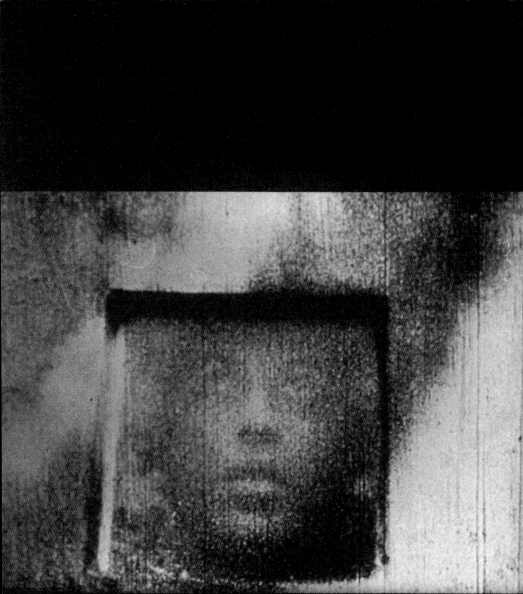

Notes

All works by Theresa Hak Kyung Cha reproduced in this volume are listed here. Works reproduced photographically are facsimiles; all others have been typeset for this volume. Facsimiles appear on pages 93, 95, 97, 99, 101, 103, 105, 107, 109, 111–112, 114, 122, 167–171, 176–190, 194–203, 207, 209–221, 224–232, 235–239, 242–258, and 263–270. Information given in these notes is taken from the Theresa Hak Kyung Cha Archive at the University of California, Berkeley Art Museum and Pacific Film Archive.

Frontispiece

Untitled (le 22 juillet) (detail), 1976; pencil on paper; 11¾ x 8½ in.

1

"audience distant relative," 1977; offset lithography on folded, two-sided card stock; seven sheets; open: 11 x 8½ in. each; folded: 5½ x 8½ in. each

The artist conceived this as a mail art piece whereby seven folded, printed pieces of card stock were mailed individually in sequence. (The seventh, not represented here, is the artist's signature card.) There is also an audio version, in which the artist reads the text aloud.

The mail art piece was reproduced in *The Solar Cavern,* a bi-quarterly poetry magazine sponsored by the Committee on Publications of the University of California, Berkeley, c. 1977. Manuel Nieto was the editor of the magazine, and Theresa Hak Kyung Cha was an associate collaborator.

It was also exhibited at the Gallerie Lóa in Haarlem, Netherlands, in February 1978. In a letter to gallerist Rivin Fannberg dated August 11, 1977, Cha wrote: "As I have told you before, this piece is divided into seven parts. Each day I will mail these envelopes. Please present these envelopes as well with the contents. The audience who come to the gallerie should be able to open from the white envelope and read the contents, as if they were personally addressed to them, involving the same gestures that everyone goes through when one receives a letter. (perhaps they should be laid out on a table according to the dates mailed)—The sound tape should be placed simultaneously."

Exilée and *Temps Morts,* from *HOTEL* (New York: Tanam Press, 1980)

Exilée was spoken by the artist in her film/video installation of the same name, first presented in the Annual Exhibition at the San Francisco Art Institute,

March 1, 1980. The written version appeared, along with *Temps Morts*, in *HO-TEL*, an anthology of artists' writings, published by Tanam Press, New York, in 1980. Reese Williams, the publisher, had been a fellow student of Cha's at the University of California, Berkeley, and would later publish *Dictée* (1982), the artist's last published work.

The text was written around the time of Cha's 1979 trip to Korea, her first since emigrating as a child in 1963. She made one more trip to Korea, in 1980, for the purpose of making a film to be called *White Dust from Mongolia*.

The Theresa Hak Kyung Cha Archive at the University of California, Berkeley Art Museum and Pacific Film Archive holds preparatory materials by the artist for the film/video installation *Exilée* and Cha's contribution to *HOTEL*. *HOTEL* also contains writings by artists Laurie Anderson, Jenny Holzer and Peter Nadin, Michael Meyers, Richard Nonas, Mike Roddy, and Reese Williams.

In *Exilée* and *Temps Morts*, Tony Whitfield writes, Cha "deals with the constant process of analysis and redefinition of language in relation to relative concepts of time and space and self as they are confronted in translation from the fact to the word to the page." (Whitfield, "Tanam Press," *COVER*, Winter 1980–81, p. 20.)

Temps Morts appeared for the first time with *Exilée* in *HOTEL*. It was written in 1980 following Cha's second trip to Korea, which included a stop in Japan.

2

"the sand grain story," 1980; typewritten text on paper with black-and-white photograph by Trip Callaghan; 14 x 8½ in.

"photo-essay," c. 1978; ten black-and-white photographs with typewritten texts on paper; photographs: approx. 7 x 9 in. each

Cha wrote the following description of this piece (in a previously unpublished text in the Theresa Hak Kyung Cha Archive):

This Photo-Essay is a documentation, a recording of events that has [sic] *occurred in the past.*

The places photographed are actually existing places of these events, except for the friend's souvenir, which exists in an imaginary space that I have tried to locate physically, to identify and name in the represented image.

I am excited by working with this concept, (to grossly simplify) of having the presence of the actual events and the actual places in the image, with the exception of the subject.

The temporal and spatial value in the represented image seems to introduce a different orientation and meaning for me—I hope to continue in developing further these ideas.

Surplus Novel, 1980; these are two different pieces with the same title, each of which consists of a porcelain cup, thread, and typewritten text on paper; cup: 1¾ x 2½ in. diameter; collections of Bernadette Hak Eun Cha Silveus and James H. Cha. Photos: Benjamin Blackwell

Each piece consists of a small porcelain cup, containing the cut-up strips of a typewritten text on paper, connected by a single black thread. Cha gave these works to her sister Bernadette and her brother James. "The texts, both serious and humorous, evoke a Beatles-type song about Yoko Ono and refer to an experience Cha had walking down the street and being called 'Yoko.'" (Constance M. Lewallen, *The Dream of the Audience: Theresa Hak Kyung Cha (1951–1982)* [Berkeley: University of California Press, 2001], p. 101.)

Cha created a similar work for her friend Noelle O'Conner the same year. It consists of five pieces of paper, each with a single typewritten word, connected with a black thread and placed in a glass medical jar. This work is currently in the Theresa Hak Kyung Cha Archive.

3

"monologue," 1977; typewritten text on paper; 11 x 8½ in.

In the spoken version of this work, aired on radio station KPFA, Berkeley, in 1977, Cha's voice alternates with a male voice and in the background is the sound of typing. The audiotape is in the Theresa Hak Kyung Cha Archive.

"i have time," 1976(?); typewritten text and handwritten edits in ink on paper; four sheets; 11 x 8½ in. each

We believe that Cha wrote this text, as well as those dated from 12 to 18 "Avril," while studying in Paris in 1976 at the Centre d'Études Americain du Cinéma through the University of California's Education Abroad Program.

On the reverse side of each of these four pages is a press-type letter: *E, E, A,* and *G,* respectively.

"time between," 1976(?); typewritten text, handwritten text in graphite, and colored pencil on yellow bond paper; 11 x 8½ in.; verso: "lament i lament your youth"

"lament i lament your youth," 1976(?); typewritten text and handwritten text in graphite on yellow bond paper; 11 x 8½ in.; recto: "time between"

"trip," 1976(?); typewritten text and handwritten text in graphite on yellow bond paper; 11 x 8½ in.

"18, avril," 1976(?); typewritten text and handwritten text in graphite on yellow bond paper; 11 x 8½ in.

"récit," 1976; typewritten text on paper; 11 x 8½ in.

> The dedication is to Hreinn Fridfinnson, an artist with whom Cha exhibited in Amsterdam, and his wife, Hlif.

"the sound is a dripping faucet," 1976; typewritten text on paper; 11 x 8½ in.

"i have taken a bite of this root," 1976; typewritten text on paper; two-sided; 11 x 8½ in.; verso: text continues upside-down, from the bottom of the page up

> The phrase "it looks for the roots of the language before it is born on the tip of the tongue" is included in an unpublished artist's statement (in the Theresa Hak Kyung Cha Archive) in which Cha explains her work.
>
> The section beginning "one folding . . ." was typed on the back of "i have taken a bite of this root," and we have thus considered it a continuation of "i have taken a bite of this root."

"fly by night," n.d.; typewritten text and rubber stamp on graph paper; 5½ x 9¼ in.

"view from the willow tree paris," 1976; typewritten text on paper; 11 x 8½ in.

"For my brother," n.d.; typewritten text on paper; 11 x 8½ in.

"long interval of silences," n.d.; typewritten text on blue bond paper; 11 x 8½ in.

"The Missing Page," n.d.; typewritten text on paper; 11 x 8½ in.

"writing conscious-unconsciously," 1978; typewritten text in black and red ink and handwritten text in graphite on paper; 11 x 8½ in.

4

Project description of *White Dust from Mongolia*, 1980; typewritten text on paper; seven pages; 11 x 8½ in. each

Poems and journal entries related to *White Dust from Mongolia*, 1980; typewritten text on paper; ten pages; various sizes

Storyboard for *White Dust from Mongolia*, 1980; pencil on graph paper; sixteen pages; 8½ x 11 in. each

Three pages of the sixteen-page storyboard are reproduced here (see pp. 167–169).

Film stills from *White Dust from Mongolia*, 1980. Photos: Benjamin Blackwell

5

Faire Part, 1976; press type and ink on envelopes; fifteen envelopes, two-sided; 5¾ x 7 in. each. Photos: Benjamin Blackwell

Faire-part means "announcement" in French.

Maquette for *it is almost that*, 1977; press type and pastel on black paper; nineteen sheets; 9½ x 12½ in. each. Photos: Benjamin Blackwell

This work is a maquette for a slide-projection piece that was exhibited at Worth Ryder Gallery in the Art Department at the University of California, Berkeley, in conjunction with the comprehensive exam for Cha's MFA degree.

Commentaire, from *APPARATUS—Cinematographic Apparatus: Selected Writings*, edited by Theresa Hak Kyung Cha (New York: Tanam Press, 1980). Photos: stills from *Vampyr* by Carl Theodor Dreyer; Reese Williams; and Richard Barnes

Cha inserted this text/image work into *APPARATUS*, which includes writings on the apparatus of cinema by filmmakers and theorists.

University of California Press
Oakland, California

© 2009, 2022 by The Regents of the University of California

Unless otherwise indicated, all images courtesy the University of California,
Berkeley Art Museum and Pacific Film Archive; gift of the Theresa Hak
Kyung Cha Memorial Foundation.

Exilée and *Temps Morts* were originally published in *HOTEL* (New York:
Tanam Press Inc., 1980). Reproduced by permision.

"Trip" is reproduced courtesy of William Callaghan III.

Designer: Nola Burger
Text: 9.25/14 Scala
Display: Univers Regular
Compositor: Integrated Composition Systems

ISBN 978-0-520-39159-8 (pbk. : alk. paper)

Library of Congress Control Number: 2009021903

Manufactured in the United States of America

31 30 29 28 27 26 25 24 23 22
10 9 8 7 6 5 4 3 2 1